Dedication

This book is dedicated to all those who strive to promote peace in a challenging world, in particular teachers and educators everywhere.

© 2019 D.B. Lewis Bryn Stowe Publications

Front Cover: David Chalmers
Rear Cover additions: Liam Kitto
Chapters 1 & 2 with additional material by Len Friskney

Publisher: *tredition GmbH*, Halenreie 42, 22359 Hamburg, Germany

ISBN

Paperback 978-3-7497-0835-2

Hardcover 978-3-7497-0836-9

eBook 978-3-7497-0837-6

One Day in December

D.B. Lewis

with Len Friskney

Wilfred Owen, The Bombardment and Scarborough in the First World War

Also by D.B. Lewis

A Little Bit of Trouble in London

Plotting Shed (Ed.)

Great Aunts and Armadillos

Return to Premantura

A Wedding in Hvar

Contents

Acknowledgements

I would like to extend my heartfelt thanks to all those who have supported this work in whatever way and in particular; my co-author Len Friskney; Stewart MacDonald and Mark Vesey of the Scarborough Maritime Heritage Centre; David and Angela Chalmers; Liz Baxter and Julie Vinson and the staff at The Clifton Hotel; David Henderson of the Western Front Association; Adrian Perry of Scarborough Civic Society; the German U-Boat Archives at Cuxhaven and Peter Weber for translating the original German texts; Meg Crane and Sam Gray of the Wilfred Owen Association; Simon Powell of the Britannia Hotel Group; Denise Gilfoyle; the Outreach Department at the Stephen Joseph Theatre; Ali Watt and John Pattison of Beach Hut Theatre Company for their constant theatrical inspiration; Robert Parkinson of Blue Sky Graphics; Mark Haynes, Elsa Monteith and all the performers and staff at Westborough Methodist Church, Scarborough; the late Joyce Bell, artist and poet, together with Jonathan Brown, lecturer at the Worker's Educational Association for inspiring my interest in Owen and the war poets; Rob Webb and Liam Kitto at Bryn Stowe Publications; Debbie Seymour, Andrew Clay, Esther Graham, Jennifer Dunne and Ruth Yoxon of Scarborough Museums Trust; Wayne Murray of the proposed Scarborough Social History Museum; Callum Nash for the cast and rehearsal photographs; all the staff and students at Scalby School, Scarborough, in particular Liz Stockhill and Paul Offord, who were so welcoming in my visits; all my colleagues in the International Police Association Writers Forum, both here and abroad for their continued support and friendship in all things literary; to Rod Jarman, Adrian Rabot and Ed Sherry of the London Policing College and Youth United for providing me with both inspiration and work; to Sue Wilkinson and The Scarborough News (formerly Evening News) for help with publicity and press cuttings; Sylvia Anderson, Mirko Esquivel, Theresa Reichelt and Nadine Otto of the publishers 'tredition' for their support and advice; Liz Dyer, North Yorkshire County English Advisor and Regional Co-ordinator for the National Literacy Trust; all the staff and volunteers at Newby and Scalby

Library, in particular Lesley Newton; Mark Marsay of Great Northern Publishing in Scarborough; Doug, Louise, Evie, Will and Hugh Stanway; Mike Bortoft at the Church of St Martin on the Hill, South Cliff; and Felix Hodcroft, Tony Howson, Mark Thompson, Heather Stoney, Jo Reed Turner, Dorinda Cass (of the Scarborough Writers' Circle), Wanda Maciuszko, Jen Thomas, Sandy Sandevik; and almost finally, to all my other fellow authors and performers in Yorkshire for their constant help in sustaining the various writing and theatrical endeavours we all seem to become involved in. A final thank you to fellow author, Maria Fuller, who as a very professional PA, has promised to sort out my incommodious filing systems, and to my wife, Sonia, for once again supervising the proof reading.

The cover imagery is an artistic photographic creation from the 2014 production of 'One Day in December' entitled 'Futility' by David Chalmers. I am grateful to him and to Angela Chalmers for the use and reproduction of their art in this work. The cover wording and rear imagery is by Liam Kitto of Bryn Stowe Publications, Scarborough.

R.I.P.

In memory of

Mark Gay

(Musical Director, 'One Day in December')

Lillian Roberts

('Voice' in the Westborough production of the play).

and

Joyce Bell

(Artist & poet; the original inspiration for this work).

7

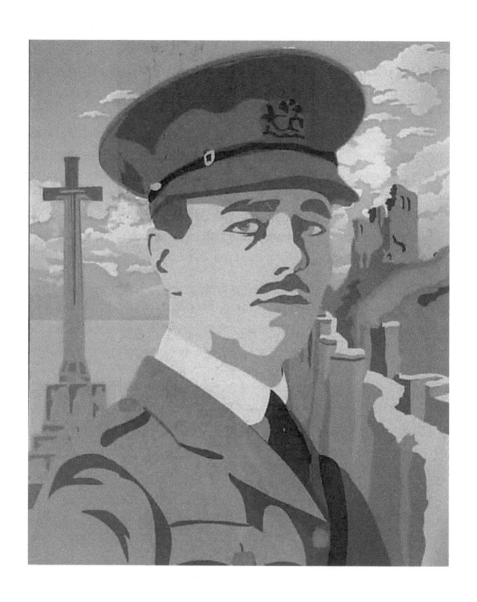

'Wilfred Owen in Scarborough'

Digital montage created by
Robert Parkinson, 2018, for Bryn Stowe Publications

Preface

'Why Remember?'

By David Henderson

The Western Front Association

The tumultuous events that occurred during 1914-18 have had a special resonance since the centenary commemorations of the Great War. In so many ways the events of that time have shaped what we are today.

The legacies of the early 20th century such as the broader cataclysm that was the eventual rise of Nazism and the Second World War, or the social and political movements of trade unionism and female emancipation, gained a heightened definition in the crucible of the Great War conflict.

To know what we are today, we should seek to understand why nations were moved to fight and why individuals on all sides rallied to their respective causes. We can understand by remembering Wilfred Owen and what he and countless other combatants saw, felt and suffered. We can remember the many who came back and endured through the difficult post-war years. And we can learn much from those who stayed at home to support the troops, coped with the stresses and strains of bereavement, and suffered countless other privations whilst feeding the furnace of total war.

The loss of the last of the veterans has put the Great War just beyond our reach. But we have been bequeathed a rich canon of literature, imagery and art from the conflict to help us better remember.

When we remember, we can learn and we can understand. And that is the very least we owe such a remarkable generation.

David G Henderson **The Western Front Association**

westernfrontassociation.com

The Western Front Association is a Registered Charity No. 298365

The logo of the Wilfred Owen Association

Introduction: The Owen in Scarborough Story

by D. B. Lewis

Thank you for delving into this book; hopefully within these pages you will find ideas, stimulation or a confirmation of your own feelings about the destructive nature of any war or any conflict, big or small. The book has been published to commemorate the message that Wilfred Owen was trying to impart to us through the poetry that had its origins in his time spent in Scarborough in 1917 and 1918.

The message tells us of the need to strive for peaceful ways of settling our global disputes and it is this that formed the justification for this book to add to the many now existing about Owen. It is in an amalgam of several separate strands of this same message that took place throughout the commemorative years of 2014 to 2018 and are now produced in this one volume.

It is hoped that many people will enjoy the book for itself, even if they have no thought of performing the piece of community theatre that appears within the story. The play was originally intended for community performances such as those produced within schools, clubs or uniformed youth organisations as a way of bringing individuals together through one performance project, but it has resonance for the general reader and all those who visit, or care for, the wonderfully enigmatic seaside town of Scarborough.

In April 2014, I wrote and produced *'One Day in December'* as a community theatre production for that year's Scarborough Literature Festival, later to become 'Books by the Beach'. It was a commemoration about the start of the First World War in 1914 and, by the end of the project over 120 people had become involved; 100 people alone being involved in the play itself.

Owen wrote over 80 'war poems', three of which feature in the play and accompanying art installation; *'Anthem for Doomed Youth,' 'Dulce et Decorum Est'* and *'Futility.'* Together with his many letters which are in their own right

a rich insight into the life and times of a war poet and his circle, they show a progression from outright angry indignation at the loss and slaughter of young lives, move through a bitter, almost helpless despair, to end up with what appears to be a softer resignation of what Owen probably saw as his own death only months away. He was killed in action leading his men across the Sambre-Oise Canal at Ors just one week before the war ended. His parents were told of his death on the very day the Armistice was signed. I was inspired by fellow writer and artist, Joyce Bell to write about Owen and Scarborough as well as highlighting the effect war had on the townspeople, then and now. The idea of staging a community theatre production linking these themes arose from that moment.

I was formerly a member of the Metropolitan Police Central Youth Team in London and later a co-ordinator with 'Youth United', working with the Prince's Charities at Dumfries House in Scotland, and it was through these experiences that I discovered the real value of bringing disparate groups of people of all ages together. The community theatre concept came directly from that experience as the groups involved in the production were drawn largely from the 'Uniformed Youth' groups of Westborough Methodist Church in Scarborough.

With the production came the first small edition of this book, in the form of an extended programme with interesting insights into the 'Owen in Scarborough' and 'Bombardment' stories. During the writing of that work, I met and worked with two local people with whom it was a real joy to be associated; Mark Vesey of the Scarborough Maritime Heritage Centre, and Len Friskney, the 'general factotum' at The Clifton Hotel, where Wilfred Owen was first billeted on his arrival in Scarborough in 1917. Both of these people readily agreed to contribute to this work and I am very grateful to them both for their dedicated efforts in helping to keep the legacy of Owen and the First World War alive in the area. In 2017, I spent some time with the students and staff at the wonderfully supportive and disciplined Scalby School in Scarborough. There, I witnessed the teaching of Owen and his legacy in the classrooms and well-

stocked library and truly felt that the teachers and educators of today were alive to the importance of the messages Owen was trying to impart.

Finally, in 2018, we, the Production Team at Bryn Stowe Publications with its theatre producing arm, 'TAFAT', launched the 'Owen Map and Trail', a guided tour around the Owen sites with the support of many of the connected Scarborough organisations. This has proved very popular and copies of the map can be obtained, free of charge, at the key places of the trail. This work provides a deeper insight into those sites and acts as a source of 'background information' for the play and its settings.

Whether you are planning to produce a piece of community theatre about the First World War, walking the Owen Trail, or visiting any of the fascinating historic sites of Scarborough connected to the story then this book should be a source of help and interest. We all hope you will find a message of hope for the future within its pages.

Central to the memory of Wilfred Owen in Scarborough, nestling just below the North York Moors and hugging the North Sea which forms a part of this story, is Len Friskney of the Clifton Hotel.

Meeting Len for the first time was like stepping back into the history books of a great long- established hotel...modest, hardworking, neat, a gentleman and character from the old school of hotel life, a life which is in danger of slipping away under the seas of plush décor, designer bars and the all too familiar cut of silver-grey, tidy corporate conformity with zero hours contracted staff.

I first went to the Clifton Hotel in search of Wilfred Owen for the short story from which the play in this work was then derived. It is a well-trodden path but, like other things in Scarborough, underrated by many – even by its own inhabitants. The Civic Society blue plaque was fading and there was little to tell me that this was one of the important venues of the Owen story as well as an essential marker on the First World War historic trail. I felt it was particularly important in the story of the futility of war with its need to continually search for an end to the conflict and global catastrophes that Owen gave us so poignantly, and powerfully, over one hundred years ago.

Talking with Len and seeing the hotel, feeling the ambient stillness together with the view from Owen's 'Five Windowed Turret Room', led to the writing of *'One Day in December'*; firstly, as a short story and then as a community stage play. I interviewed Len by his fascinating Owen foyer display in the Clifton Hotel on a number of occasions. He came into the offices of the theatre company I was then running at Woodend, the creative arts centre in The Crescent, Scarborough and there, he recounted the story which he has now graciously agreed to have used in this work.

Fig 2: Part of Len Friskney's 'Owen' Display at The Clifton Hotel

Chapter 1:

Wilfred Owen in Scarborough

by Len Friskney

These two chapters are about Wilfred Owen, the First World War and Owen's association with Scarborough, in particular with the Clarence Gardens Hotel, now The Clifton Hotel on Queen's Parade. In the foyer of the hotel is a display dedicated to the poet and soldier which I have put together and maintained over the past few years. Owen was posted to the hotel after he had become a patient at Craiglockhart War Hospital near Edinburgh after suffering from 'neurasthenia' ('Shell Shock' or Post-Traumatic Stress Disorder, PTSD, as we would now call it). He was stunned after having an accident at Bouchoir in France where he fell down a well. He resumed duties after that incident, but in April 1917 a shell exploded near him whilst he was asleep. His Commanding Officer recognised the symptoms of shell shock and sent him back to 'Blighty'. While in the hospital he was examined by a Dr Brock who favoured an 'Occupation Cure', and so Owen was encouraged to continue writing and in so doing this helped him to recover as well as helping to develop his own poetic style. Owen had an interest in writing poetry from a young age.

Owen's thoughts, feelings, emotions and his own experiences of the horrors of war were expressed in his poems as a serving soldier and his phrase 'My subject is war and the pity of war. The poetry is in the pity' is well known, appearing as it does on the War Poets' Memorial in Westminster Abbey.

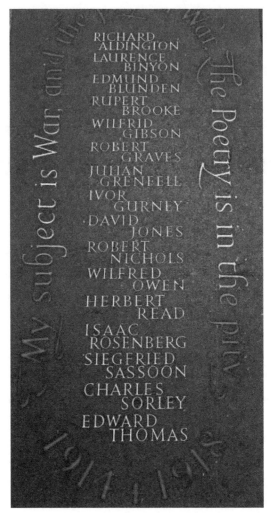

Fig 3: The War Poets' Memorial at Westminster Abbey

Scarborough has had its share of famous people over the years who either came to stay for short periods or were born here and these are commemorated in the many blue plaques that can be seen around the town including the one of Wilfred Owen at the Clifton Hotel. Owen was sent to the hotel, 'The Clarence Gardens' as it then was, when he was posted to Scarborough after suffering from what would later be called 'Shell Shock'. This chapter is dedicated to him, not only as a poet whose words have been immortalised, but as a man of great courage and leadership.

Many books have been written about Wilfred Owen and his poems have been frequently published. This short tribute is in no way a complete biography which can be found within those publications. But Owen already knew of Scarborough of course when he came with his family on holiday in 1905 at the age of 12 and his cousin, May Davies, had lived in the town for some years.

Wilfred Edward Salter Owen was born in Oswestry in 1893; his family eventually moving to Shrewsbury and his interest in poetry started at an early age. When the First World War broke out, he was a most unlikely person to choose a military career but he became a soldier and a respected officer. He expressed the futility of war, the suffering, the horror and the death as well as his experiences of that time through his poems. He became one of the great First World War poets and, in the end was well respected as both a poet and a soldier.

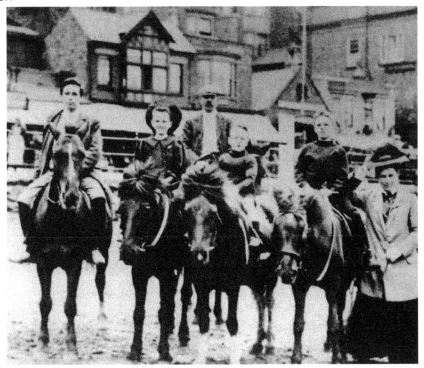

Fig 3a: Wilfred Owen (left) with his family in 1905 at Scarborough's South Bay.

Owen had enlisted into the Artist's Rifles in 1915, was commissioned in 1916 and became an officer in the 5th (Reserve) Battalion of the Manchester Regiment with whom he went to France on active service. In 1917, suffering from shell shock, he was sent to the Casualty Clearing Station at Gailly in France from where he was eventually transferred, via Wales, to Craiglockhart War Hospital in Slateford near Edinburgh where he met other poets including Siegfried Sassoon and Robert Graves who became his inspiration. His own style was developed there and writing poetry became a therapeutic aid in his recovery.

On 28th October 1917, he appeared before the medical board who cleared him to return to his unit and on the 24th November 1917, he reported to the Clarence Gardens Hotel, Scarborough for 'light duties'. On arrival, and after a night spent in the Victoria Hotel in West Square, he became second in command to Lieutenant-Colonel Mitchell. This involved finding accommodation for fellow officers and organising the domestic staff. In one of the many letters to his mother, Susan, he described his work;

"I have to control the household, which consists of some dozen Batmen, 4 Mess Orderlies, 4 Buglers, the cook (a fat woman of great skill) two female kitcheners, and various charwomen! They need driving. You should see me scooting the buglers around the dining room on their hands and knees with dustpan and brush! You should hear me rate the Charwoman for Lavatory basins un-clean.

I am responsible for finding rooms for the newcomers, which is a great worry as we are full up. This means however that I have a good room for myself as well as my office!
I kept two officers under arrest in their rooms.........
I get up at 6.30 to see that breakfast is ready in time....

There was a guest night yesterday, which meant a gorgeous meal, whose menu I am ashamed to give you. It kept my house-lads sweating until after midnight!"

Being appointed 'Major-domo', as he called it, he was able to choose his own room. He does not state which room this was by number but my investigations suggest that it was one of the 'turret rooms' that mark out the hotel. In his letters, Owen mentions that he was in a room where 'the ceiling was so low that even a small man would have to stoop'. In the present room 493 a massive 'T' girder holds up the roof of the tower or 'turret' as we call it, so this suggests it was indeed this room in which he was to stay.

In another letter Owen writes to his mother, Susan, that '...I sit in the middle of my five windowed turret and look down upon the sea...' It is quite possible although this in in part, conjecture, that he may have taken bedroom 367 on the third floor which still has a five windowed 'turret' and is right below room 493 as his office for his military duties, and used 493 as his sleeping quarters where he could escape from his duties for 'peace and solitude' to concentrate on his poetry.

During alterations to room 493 some years ago, two alcoves on the left and right of the room were blocked off but in the centre of the main wall, the position of the hearth from Owen's time is still in evidence under the carpet and below the headboard. A fire surround from another room has been placed in this room to give an effect of how it would have been at the time Owen wrote 'Miners'.

Between 1917 and 1918, over 85 of Owen's poems and fragments can be attributed to his pen whilst at Craiglockhart, Scarborough and Ripon. Although Owen was only at Scarborough for six months in total and his time at Craiglockhart and Ripon were clearly profound, he either drafted, wrote, or revised about 17 of his most significant poems in Scarborough plus a number of sonnets and other fragments. Following my conversations with Dominic Hibberd during his visit to the Clifton Hotel in 2013, I researched the works and the

letters he wrote to both his mother and other poets, and believe these, at least, to be the ones he wrote in Scarborough;

November 1917 - March 1918 (Clarence Gardens Hotel)

'I Saw his Round Mouth's Crimson'
'Apologia Pro Poemate Meo'
'Le Christianisme'
'The Rime of the Youthful Mariner'
'Who is the God of Canongate'
'Miners'
'A Tear Song'
'A Terre'
'The Show' (Drafted)
'Hospital Barge'

June 1918 (Burniston Barracks)

'The Calls'
'Training'
'The Send Off' (Revised)
'The Parable of the Old Man and the Young'
'Disabled' (Revised)
'Kind Ghosts'
'Soldier's Dream' (Revised)
'I am the Ghost of Shadwell Stair' (Drafted Clarence Gardens, revised Burniston Barracks)
'The Sentry' (Drafted Craiglockhart, continued Burniston Barracks)
'Spring Offensive' (Revised in France)

Some of Owen's best-known works came from the 'Turret Room' including *'Apologia Pro Poemate Meo'*. *'Hospital Barge'*, *'The Rime of the Youthful Mariner'*, *'A Tear Song'*, *'The Show'*, *'A Terre'* and *'Miners'*. The inspiration for this

latter poem may well have come as he gazed into the small coal fire in his room after he had read of the 155 men and boy miners who had died in a pit explosion at Podmore Hall Colliery in Halmerend in January 1918 on the North Staffordshire Coalfield ('The Minnie Pit Disaster'). It may well have reminded him of the similarly dangerous work the soldiers of the Royal Engineers were undertaking in trying to tunnel under the enemy held positions at 'The Front'.

Eventually, with other officers in Scarborough he was posted to the Northern Command Depot in Ripon for a short period of battle re-training after being passed fit for front line duties. He then returned to Scarborough and to Burniston Barracks before embarking for France. Little is left now of the barracks save a 'pill box' on the edge of the golf course and the names of the housing estate streets built on the old barracks site; 'Green Howard's Drive', 'Signals Court', 'Cavalry Court', 'Hussar Court', and 'Strensall Drive' (named after the military camp in York). The estate is on the right-hand side of the A167 travelling north towards Whitby just past the Open-Air Theatre and Waterpark.

This time his accommodation was not so luxurious as when he had been at the hotel; it was a tent outside the main gate of the camp where, between his duties as the Battalion Messing Officer and training new recruits, he managed to write further poems including; *Spring Offensive'* (begun at Scarborough), *'Disabled'* (revised), *'The Send Off '* (revised), and *'The Kind Ghosts',* amongst other works.

He was delayed going back into the front line due to an outbreak of 'Spanish Flu' at the barracks when about 30 officers went down with the infection and where many soldiers were dropping on parade. Owen however remained unaffected. In August 1918 he returned to France and took with him a postcard of Scarborough to 'remind him of home'. In October 1918 he was in action at Joncourt in France where he was recommended for the Military Cross for his actions. The citation, which appeared in the London Gazette in 1919, reads;

'For conspicuous gallantry and devotion to duty in the attack on the Fonsomme Line on 1ˢᵗ/2ⁿᵈ October 1918. On the company commander becoming a casualty, he assumed command and showed fine leadership and resisted a heavy counter attack. He personally manipulated a capture of an enemy machine gun from an isolated position and inflicted considerable losses on the enemy. Throughout he behaved most gallantly.'

Wilfred Owen was killed in action on the 4ᵗʰ November 1918 in an attack on a heavily defended position at De La Motte Farm near the village of Ors, the main obstacle being the Sambre Canal which had to be crossed. After the battle his body was found on the enemy side of the canal and his grave is in the communal cemetery at Ors in France with many of his comrades. The news of his death was not received by his parents until the 11ᵗʰ November, Armistice Day.

Many years have passed since his death but Wilfred Owen's reputation has grown and he is now regarded by many as one of the greatest poets of that era who found inspiration in his own war experiences and the town of Scarborough should be proud of that association. Scarborough Civic Society recognised this when the blue commemorative plaque was unveiled near the Turret Rooms at The Clifton Hotel by Peter Owen, Wilfred's nephew, in 1999. In 2011, The Wilfred Owen Association made me an honorary member – I was very pleased about that.

Fig 4:: Owen's grave at Ors in France
(Len Friskney)

Chapter 2:

Life at The Clifton Hotel

by Len Friskney

I came to work at The Clifton Hotel in June 2000; it was owned by English Rose then, before Britannia took it over, and as soon as I started, the hotel's connection to Wilfred Owen was obvious – people just kept asking about it. I think the importance of Owen, the hotel and the message many of the war poets were trying to convey to the world, then and since, wasn't really appreciated by the owners. I think it is a bit more now although neither the hotel nor Scarborough Borough Council make any particular fuss about the Owen connection; this is a popular busy hotel throughout the year anyway with stunning views over the North Bay and the Castle. It's a lovely place to stay with the added interest of the history for those that like it; a sort of added value I suppose and not the main reason people come.

Scarborough must have seemed very 'Royalist' during Queen Victoria's reign especially on the north side with street names such as 'Queen's Parade', 'Victoria Park' (and Avenue), 'Albert Street', 'Royal Albert Drive', 'Sandringham Street', 'Clarence Gardens' and 'Alexandra Gardens'. The original Alexandra Hotel, one of The Clifton Hotel's two predecessors on the present site, was twice as big as the present hotel and covered much of what is now the hotel car park as well as the present hotel site itself. Shortly after the construction was completed and the new Alexandra Hotel was opened to the public on

Monday 18th July 1864, the local newspaper, 'The Scarborough Gazette', published a complete list of the names of every guest staying in Scarborough Hotels as well as the guest houses and public houses with accommodation. In this way it is recorded that the Alexandra Hotel had over 250 guests in the August of 1864. However, it has always seemed to me that these figures might just have been a way of enhanced advertising by the hotel itself and they may have been 'gilding the lily' as they were possibly struggling to fill their rooms at the time.

When the present Clifton Hotel was taken over from 'English Rose' by 'Britannia', extensive alterations took place where an overflow dining room and the 'Alexandra Suite' were converted into bedrooms. There, a piece of history was revealed when a workman found, under the floorboards, an envelope addressed to 'The Prop. Alexandra Hotel, Scarborough'. It had the post mark 'Scarborough 1900' with a light blue Queen Victoria one penny stamp and enclosed in the envelope was a railway timetable for the following year, 1901, sent by the Great Central Railway Company.

This was at least proof that the hotel had been in existence up to that time but a major alteration took place in 1901 when half of the hotel was demolished for reasons that are as yet unknown but might have been to do with the trading pattern. Extended gardens were made from the site and the hotel's name was changed from 'Alexandra' to 'The Clarence Gardens Hotel'.

The hotel's third name change was in 1938 and it still has that name today, 'The Clifton'. In a brochure of the 1950s the hotel boasts;

'Occupying a unique and unrivalled position overlooking the North Bay, The Clifton Hotel may assuredly claim the finest situation on the North East coast. From the windows splendid views may be obtained of the sea and sands extending from the Castle Hill in the south to the Whitby Moors over 20 miles to the north.'

The hotel itself is a place full of character, from the cellars in the basement to the five windowed turret rooms, there is history in every joint and corner, a bit like myself I suppose!

Many people keep returning here; it is quaint, quiet and homely and people seem to like our sort of friendliness. And the views over the bay and the castle are simply stunning. When I started, I wanted to find out more about the general history of the hotel right back to when it started and as the Clarence Gardens as it was by 1914, but the Owen connection became more important and, as I found out more and more, so it became all absorbing – all the connections to Sassoon and the Sitwell's for instance.

This spread to include the First World War history of Scarborough – it was an important place in the war's development after the 1914 bombardment, and I have been in a lot of correspondence with the German museums who have sent me extracts of the records from their side; some of it in highly ornate Gothic German print. As with all old buildings in Scarborough, the Clifton has its share of

These items were found on Tuesday 2nd July 2013 by the workmen in the Alexandra Suite while the renovations for the new bedrooms were taking place.

Fig 5: Extract from the Owen display at the Clifton Hotel

mysterious 'goings on' with sightings, feelings and many unexplained happen-ings in the hotel. Many guests have mentioned 'feeling the presence' around the rooms and Mark Riley in his book *'Haunted Scarborough'* refers to it. One of the guests, a medium, claims to have seen an image of a brown clad man in a flat cap walking across a corridor and to have seen soldiers in the foyer.

I haven't seen anything myself but there is definitely 'a feeling' at times. In the book, the hotel is mentioned in a paragraph entitled 'Non-Paying Guests';

> *'..the hotel has become better known locally for different guests, its non-paying guests, one of which is believed to be a poltergeist. Clean-ers and other staff at the hotel have discovered all twenty-bedroom doors on the second floor open at the same time. On other occasions, all of the television sets on this floor have switched on at the same time; staff say this only ever seems to happen after the guests have left...'*

Further stories are added by the author but when the Britannia group purchased The Clifton, many alterations took place where new bedrooms were created from the Alexandra Suite. When work was finished and the security cameras were installed, perhaps it was then that the 'spirits' may have been disturbed? The CCTV cameras picked up many 'movements' flowing to and fro in fast and slow time of all shapes and sizes, going through walls and upwards and downwards. They had been disturbed and it did not look like dust. Sceptics may scoff but this has been seen on CCTV. In another incident, two ladies who were mediums staying at the hotel felt a strong presence of soldiers; in the foyer and in the dining room and one on the fourth floor. In another incident, a lady requested to move rooms as she claimed there were too many 'orbs floating around'. She took a photo of them as she sat on the bed but the photo is inconclusive to look at.

And even today on one of the corridors there is, at times, a strong smell of cigar smoke although this is a non-smoking hotel and has been for many years. Housekeeping staff have heard muffled voices from rooms; on knocking and

entering there has been no one present and then there is the TVs switching on together that Mark Riley mentions in his book. In 2017, a very unexplained incident happened. At the rear of the hotel there are storage areas for the kitchen produce. A *commis* chef went through the main store and into an inner store to get some stock, leaving this inner room open. On his return, the room was shut and he was unable to reopen it. It was if something was blocking the door. He asked for assistance and it took all the strength of two men to open it. It was found that a heavy freezer had blocked the door from the inside of the store. At first it was thought that a practical joke was being played on the chef but there is no rear or side entrance or any window in that store; the only access was the door.

Then there is the Owen connection when the hotel was commandeered for military use in the First World War. As I said the quotation I like best from Owen at that time is this one: 'My subject is war and the pity of war. The poetry is in the pity.' This is in my favourite Owen book - Dominic Hibberd's *'Wilfred Owen - the Last Year'* published by Constable in 1992. Sadly, Hibberd died in 2013 but he came here for some of his later research and we spoke together about Owen and I have a signed copy of his book. I like to think Owen might have written that line in the 'five windowed turret room' as he describes it in his letter.

The room (now 493) is situated on the top floor of the hotel clearly visible from the cliff and standing proudly over the bay. In one of the letters to his mother, Owen says he loved to sit in the middle of the room watching the sea. Well, you can't see the sea if you sit in the middle of the top room - you need to stand but you can from the room below (367). So, my take on this is that he probably took both rooms and worked in the one below for his military duties, sleeping in the one above.

The hotel was commandeered for military use for the second time at the outset of the Second World War when, with The Boston, just south of the hotel in Queen's Parade, the two hotels were used to house the Royal Naval School

of Music. This later became the Royal Marines School of Music and a number of musicians are known to have married local girls.

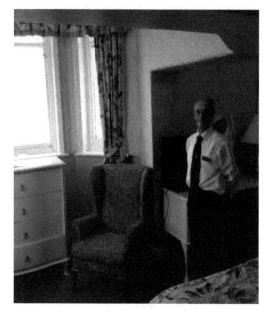

Fig 6 and 7: Len Friskney in the rooms probably used by Owen. Note the low beam.

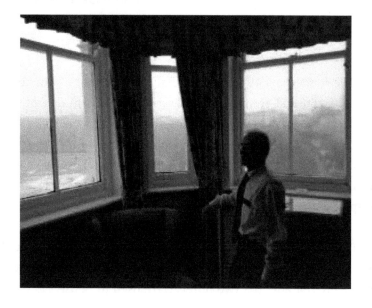

Fig 8: The Clarence Gardens Hotel in the late 1890s

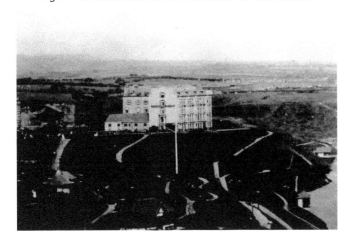

Fig 9: (Author's collection) The Clifton Hotel today, the 'Turret Rooms' clearly visible.

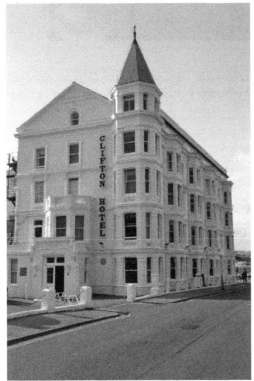

Fig 10: (Below) The view from Room 367 of the hotel. (Len Friskney)

Fig 11: In this picture the hotel is in the distance and the Clarence Gardens are to the right. In the foreground is Scarborough Pier which was demolished by rough seas in 1912.

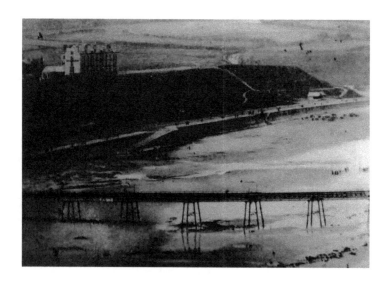

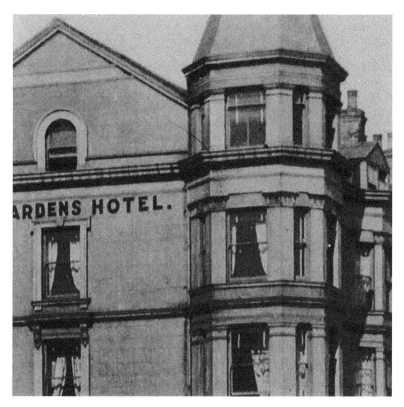

ŋ 12: This photograph, from a promotional postcard of the Clarence Gardens Hotel ̊ted 1918, is an enlargement showing the top two turret rooms and shows that there were still blinds in the windows mentioned by Owen.

en sometimes wrote to his mother in the third person;

'There were days that winter' (1917) 'when the sun shone so dazzling that he half closed the blinds and imagined he was back in the South of France, on other days there was nothing but fog, or the wind blew until the air was crystal clear and the bay white with foam.'

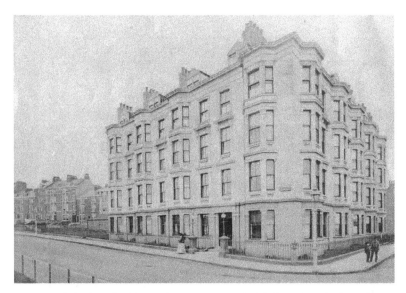

Fig 13: Picture of the hotel without the turrets; probably from just before the turn of the 20th Century.

Scarborough, being a seaside resort even in the First World War, meant that postcards were still available to buy and the postcard in the Owen foyer display in the hotel is an original, a copy of which Owen bought and placed inside his own copy of *'Swinburne's Poems and Ballads'* dated 1918 perhaps to remind him of his time in Scarborough. I have a copy of this book which I have placed in the Owen display in the hotel.

Fig 14: Another view of the hotel from Queen's Parade circa 1910

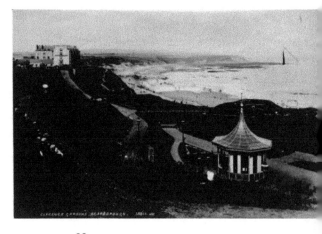

Army Form A. 45.

PROCEEDINGS OF A MEDICAL BOARD

assembled at...... WELSH HOSPITAL NETLEY. on.....25..6..17.

by order of.....A.C.I. 423 dated 9/3/17..

for the purpose of examining and reporting upon the present state of health of

(Rank and Name)...2/Lieut. Wilfred Owen........ (Corps)5/attd.2/Manchesters.

Age... 24 ... Service 1.9/12 ...Disability.........Neurasthenia (143)..................

Date of commencement of leave granted for present disability..............................

Date on which placed on half-pay for present disability..............................

The Board having assembled pursuant to order, and having read the instructions on the back of the form, proceed to examine the above-named officer and find that

In March 1917 he fell down a well at Bouchoir, and was momentarily stunned. He was under medical treatment for 3 weeks, and then resumed duty. About the middle of April he was blown up by a shell explosion while he was asleep. On May 1st, he was observed to be shaky and tremulous, and his conduct and manner were peculiar, and his memory was confused. The R.M.O. sent him to No. 41 Sty.N.Gailly where he was under observation and treatment by Capt. Brown R.A.M.C, Neurological Specialist for a month. On 7/6/17 he was transferred to No. 1.G.H. Etretat, and on 16/6/17 to the Welsh Hospital Netley. There is little abnormality to be observed but he seems to be of a highly strung temperament. He has slept well while here. He leaves Hospital to-day transferred to Craig Lockart War Hospital, Edinburgh for special observation and treatment.

The Board will classify the officer under one of the following categories, the probable period of unfitness for the higher categories being stated.

1. Fit for General Service..................................... Unfit six months.

2. Fit for service in a Garrison or Labour
 Battalion abroad: *No officer likely to be*
 fit for general service within six months } Not applicable.
 should be classed in this category

3. Fit for Home Service.. Unfit three months.

4. Fit for Light Duty at Home................................. Unfit three

5. Requiring indoor hospital treatment—
 (a.) In an Officers' Hospital........................ Yes.

 (b.) In an Officers' Convalescent Hospital........ Not applicable.

6. (a.) Fit for light duty at a Command Depôt...... Not applicable.

 (b.) Fit for treatment only at a Command Depôt.... Not applicable.

7. In very special cases such as tuberculosis leave
 not exceeding six months may be recom-
 mended by Medical Boards for special } Not applicable.
 treatment, the Board giving detailed reasons
 for any such recommendation

8. Was the disability contracted in the service?........ Yes.

9. Was it contracted under circumstances over }
 which he had no control?. } Yes.

10. Was it caused by military service?................... Yes.

11. If caused by military service, to what }
 specific military conditions is it } Active Service in France.
 attributed? }

12. If the disability was not caused b. }
 military service, was it aggra- } Not applicable.
 vated thereby, and if so, by what }
 specific military conditions? }

Officer's } Welsh,
Address } Monkmoor Road, Shrewsbury.

...........................President.
LIEUT.COLONEL R.A.M.C.

Fig 15: Owen's medical report from 1917 (Len Friskney collection)

My Favourite Owen Poems *by Len Friskney*

My favourite poem? Difficult, he was such a powerful poet, but *'Miners'* is one, *'Futility'* is another. And *'Dulce et Decorum Est'*. I like to think about the ones he either wrote, drafted or revised at the hotel here - *'Anthem for Doomed Youth'* for instance he probably wrote convalescing at Craiglockhart War Hospital near Edinburgh but revised at Scarborough. That's a haunting poem isn't it? A lost generation. Owen's description of his time in Scarborough can be found in his *'Collected Letters'* (ed. Harold Owen and John Bell, 1967)) and *'Selected Letters'* (ed. John Bell 1985.) I had a correspondence with Peter Owen about his uncle before the latter died in 2018.

Anthem for Doomed Youth

What passing-bells for these who die as cattle?

Only the monstrous anger of the guns.

Only the stuttering rifles' rapid rattle

Can patter out their hasty orisons.

No mockeries now for them; no prayers nor bells;

Nor any voice of mourning save the choirs, –

The shrill, demented choirs of wailing shells;

And bugles calling for them from sad shires.

What candles may be held to speed them all?

Not in the hands of boys but in their eyes

Shall shine the holy glimmers of goodbyes.

The pallor of girls' brows shall be their pall;

Their flowers the tenderness of patient minds,

And each slow dusk a drawing-down of blinds.

1915

Dulce et Decorum Est

Bent double, like old beggars under sacks,

Knock-kneed, coughing like hags, we cursed through sludge,

Till on the haunting flares we turned our backs

And towards our distant rest began to trudge.

Men marched asleep. Many had lost their boots

But limped on, blood-shod. All went lame; all blind;

Drunk with fatigue; deaf even to the hoots

Of tired, outstripped Five-Nines that dropped behind.

Gas! Gas! Quick, boys! – An ecstasy of fumbling,

Fitting the clumsy helmets just in time;

But someone still was yelling out and stumbling,

And flound'ring like a man in fire or lime...

Dim, through the misty panes and thick green light,

As under a green sea, I saw him drowning.

In all my dreams, before my helpless sight,

He plunges at me, guttering, choking, drowning.

If in some smothering dreams you too could pace

Behind the wagon that we flung him in,

And watch the white eyes writhing in his face,

His hanging face, like a devil's sick of sin;

If you could hear, at every jolt, the blood

Come gargling from the froth-corrupted lungs,

Obscene as cancer, bitter as the cud

Of vile, incurable sores on innocent tongues, –

My friend, you would not tell with such high zest

To children ardent for some desperate glory,

The old Lie: *Dulce et decorum est*

Pro patria mori. **1917**

Miners

There was a whispering in my hearth,
A sigh of the coal.
Grown wistful of a former earth
It might recall.

I listened for a tale of leaves
And smothered ferns,
Frond-forests; and the low, sly lives
Before the fawns.

My fire might show steam-phantoms simmer
From Time's old cauldron,
Before the birds made nests in summer,
Or men had children.

But the coals were murmuring of their mine,
And moans down there
Of boys that slept wry sleep, and men
Writhing for air.

And I saw white bones in the cinder-shard,
Bones without number.
For many hearts with coal are charred,
And few remember.

I thought of all that worked dark pits
Of war, and died
Digging the rock where Death reputes
Peace lies indeed.

Comforted years will sit soft-chaired
In rooms of amber;
The years will stretch their hands, well-cheered
By our lifes' ember.

The centuries will burn rich loads
With which we groaned,
Whose warmth shall lull their dreaming lids,
While songs are crooned.
But they will not dream of us poor lads
Left in the ground.

February 1918

(Fig 16: The fire surround from Owen's time.)

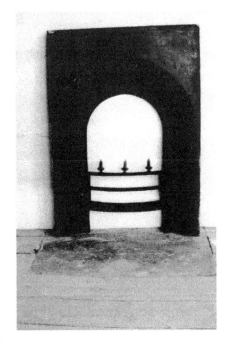

Futility

Move him into the sun—
Gently its touch awoke him once,
At home, whispering of fields half-sown.
Always it woke him, even in France,
Until this morning and this snow.
If anything might rouse him now
The kind old sun will know!

Think how it wakes the seeds,—
Woke, once, the clays of a cold star.
Are limbs, so dear-achieved, are sides,
Full-nerved—still warm—too hard to stir?
Was it for this the clay grew tall?
—O what made fatuous sunbeams toil
To break earth's sleep at all?

May 1918

Fig 17: 'The Futility of War' by Angela Chambers (See Chapter 7).

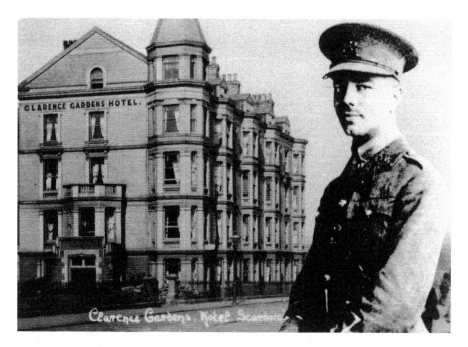

Fig 18: A postcard montage sold by Len Friskney to raise funds for The Wilfred Owen Association.

Fig 19: The Owen 'Blue Plaque' from the rear of the postcard.

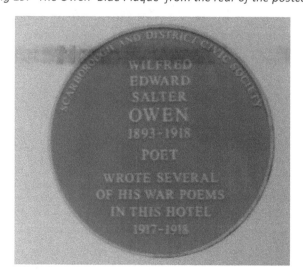

40

Chapter 3:

The Owen Map and Trail

Introduction to The Map and Trail

In 2017, Bryn Stowe Publications decided to deliver a commemorative se-
ries of events in Scarborough to mark Wilfred Owen's time in the town.
These were planned as a museum display, a lecture, a book launch, the de-
sign and implantation of an 'Owen Trail' and the replacement of the Blue
Plaque at the Clifton Hotel. The events included a recital and lecture by
Sam Gray of the Wilfred Owen Association who recorded the event in his
book, *'Reciting Wilfred Owen';*

*'In Scarborough, Wilfred lived at the Clarence Gardens Hotel, which
he also managed, from 24th November 1917 to 12th March 1918.
The building remains unchanged on the exterior and still operates
as a hotel, now called the Clifton. There was not room for a
presentation there but the director of the Scarborough Museum and
Art Gallery kindly offered us a room, just able to hold the fifty
audience, plus a small overflow in the passage! Again, I recited the
poems, Yvonne (Morris) read the letters to Susan, and this time a
local actor, Felix Hodcroft, volunteered to read Wilfred's letters to
male recipients and some short explanations and references to
Scarborough which I inserted. As before, my wife Cherry Gray*

operated the computer and screened the seventy slides of the Man-
uscripts, and photos of old and contemporary Scarborough and war-
torn France.'

The biggest event was the display at the Scarborough Art Gallery. This was planned and delivered by Jennifer Dunne of Scarborough Museum's Trust to avoid duplication. This was followed by the launch of the 'Owen in Scarborough Map and Trail' delivered by Bryn Stowe Publications. The launch took the form of an illustrated talk by the author to a full house at Newby and Scalby Library, now being run as a charity by a dedicated group of trustees and volunteers, with the proceeds going to the library. The map was designed by Robert Parkinson of Blue-Sky Graphics and Design in Scarborough to a brief that suggested an image of the railway posters of the time. Robert interpreted this brilliantly and the map was instigated and produced by Bryn Stowe Publications of Cloughton through the kind support of most of the organisations shown on the map. The montage image of Owen against a backdrop of Scarborough is shown at the beginning of this book as an acknowledgment to both Owen and to the artist.

The imagery and the map itself have both received excellent reviews and the maps have reached many parts of the globe through the appreciative tourists who stay at the Clifton Hotel. An initial run of 5000 copies was distributed at the key points of the trail and has proved very popular indeed. A second print run with additional sponsors was being planned for delivery in late 2019.

Arrangements to renovate the blue plaque which formed part of the commemoration are on-going at the time of publication and this brief written history of Owen in Scarborough to mark his time here formed the final part of the commemoration events.

Clearly on a map trail such as this, only brief details of the places could be described so that the following is a more detailed description about the 12 key locations and some of the more important events with which they are associated.

Fig 20: The front of the map before folding:

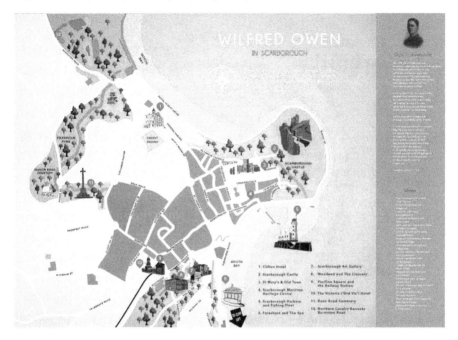

Fig 21: The reverse of the map before folding:

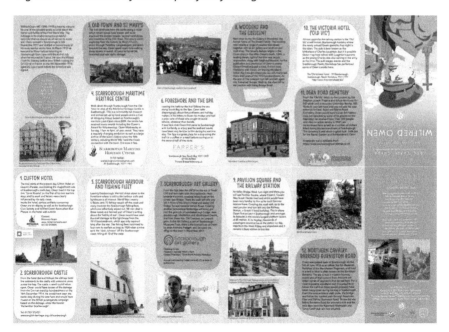

1. The Clifton Hotel

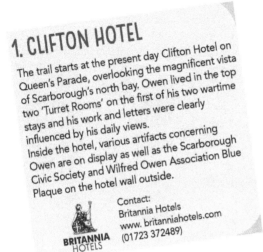

1. CLIFTON HOTEL

The trail starts at the present day Clifton Hotel on Queen's Parade, overlooking the magnificent vista of Scarborough's north bay. Owen lived in the top two 'Turret Rooms' on the first of his two wartime stays and his work and letters were clearly influenced by his daily views.

Inside the hotel, various artifacts concerning Owen are on display as well as the Scarborough Civic Society and Wilfred Owen Association Blue Plaque on the hotel wall outside.

Contact:
Britannia Hotels
www. britanniahotels.com
(01723 372489)

BRITANNIA HOTELS

Fig 22: The Owen Trail starts at The Clifton Hotel and the first image to appear is a postcard designed by Len Friskney of the hotel. He designed and sold this item to raise funds for the Wilfred Owen Association. Popping into the hotel is well worth the effort because in the foyer Len has put together a small display of Owen and his connection to the hotel.

Len also has a few commemorative items from the Association on sale and the Owen Map is available free of charge in the lounge. Outside, the Civic Society blue plaque commemorating Owen can be seen on the south wall. It is this hotel as it is today that features in the story and play *'One Day in December'* where the fictional characters are Freddie, the son of the hotel proprietor, his gran and his girlfriend, Roxanne. Copies of this book can also be obtained from the hotel.

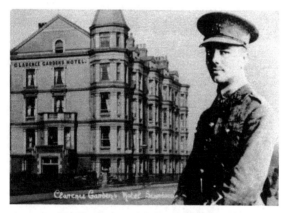

Fig 23: Postcard showing the Clarence Gardens Hotel and Wilfred Owen by Len Friskney

2. Scarborough Castle

2. SCARBOROUGH CASTLE

From the hotel the trail follows the cliff top hotel line eastwards to the castle with extensive views across the bay. The castle is worth a visit when open. Owen would have known of the damage from the German warship bombardment on the 16th December 1914. He would have seen the castle daily during his time here and would have mused on the British propaganda campaign based on the damage under the banner 'Remember Scarborough'.

Tel: 01723 372451
www.english-heritage.org.uk/scarborough

Fig 24 and 25: Owen would have seen Scarborough Castle every day of his time at The Clarence Gardens Hotel. By the time he first arrived in 1917, Scarborough was no stranger to war and The Bombardment, with its very dramatic *'Remember Scarborough'* propaganda, would have been a constantly painful reminder to the townspeople. The Castle was a military base during war time and is worth a visit up the steepish hill for both the historic interest and the magnificent panoramic views. There is a well-stocked shop containing many gifts suitable for all age ranges and particularly for children interested in history. There is also a small café situated within the castle buildings but check for opening times and events, especially during the winter months. The site is now managed by English Heritage.

3. Old Town and St Mary's

3. OLD TOWN AND ST MARY'S

The trail continues from the castle along a route which Owen would have known well as he explored the auction houses, second hand shops and hostelries of the Old Town. This area is worth exploring from the historic St Mary's Church, down through Paradise, Longwestgate and down towards the sea. Owen spent much time walking these streets in search of items to furnish his intended post war idyllic cottage.

Fig 26: Owen wrote to his mother, Susan, that he had spent time walking through the streets of Old Town seeking out items of furniture for his idyllic post war cottage in which he planned to live. The area today is charming, with cobbled streets, buildings dating back their history to the middle ages and fascinating walkways and ginnels to explore. There is a real sense of taking a trip back in time here and many of the buildings would have been known to Owen. St Mary's church dominates the skyline here and much history can be seen from the Civil War damage of the 1640s through to writer Anne Bronte's grave visited by thousands of Bronte pilgrims every year. Owen wrote to his mother that on 27th January 1918 he had been to church, (probably St Mary's), after which he had been to see friends of his cousin May. In his letters to his mother, Owen describes Scarborough;

'This afternoon is all blanketed in sea-fog, but it is not at all desolate but quite a cosy kind of fog. All the same Scarborough is a moribund sort of place. I would rather the back of behind Edinburgh than all the Front at Scarboro'…'

and later;

'I could make you like Scarborough. Last night I took an artist johnny (sic) – called Claus (a fat old tub) – to the Scarborough, where there's not a house built since 1780, not a street wider than Claus, and miles of it, miles of glorious eighteenth century...'

Finally, either he seems to feel he has not done justice to the town or perhaps he was just trying to persuade her to come and stay near him when he tells his mother;

'In truth I am very comforted in Scarboro'. 'For everything' that Solomon mentions, 'there is time' except singing and dancing. Last week I went to an excellent play, a really charming comedy – Quinney's by Vachell... For your health you might just as well have come here. That Scarborough is bleak is a figment of the imagination; Even when it's dull and rainy, it is warm.'

Fig 26a: A postcard sent by Owen to his cousin Leslie Gunston from Scarborough, hinting at his shopping trips in Old Town for the post war cottage he had planned.

4. Scarborough Maritime Heritage Centre

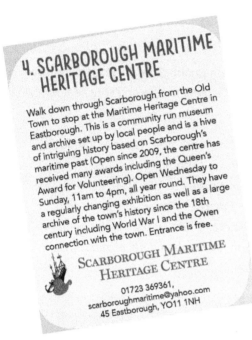

4. SCARBOROUGH MARITIME HERITAGE CENTRE

Walk down through Scarborough from the Old Town to stop at the Maritime Heritage Centre in Eastborough. This is a community run museum and archive set up by local people and is a hive of intriguing history based on Scarborough's maritime past (Open since 2009, the centre has received many awards including the Queen's Award for Volunteering). Open Wednesday to Sunday, 11am to 4pm, all year round. They have a regularly changing exhibition as well as a large archive of the town's history since the 18th century including World War I and the Owen connection with the town. Entrance is free.

SCARBOROUGH MARITIME HERITAGE CENTRE

01723 369361,
scarboroughmaritime@yahoo.com
45 Eastborough, YO11 1NH

Fig 27: 2014 marked the centenary of World War One and the tragic bombardment of an innocent seaside town, Scarborough. 1914 was a good season for the town but by the declaration of war on August 4th, the London and North Eastern Railway announced rail excursions to the North East were cancelled until further notice.

At breakfast time on 16th December, nine days before Christmas, the German battle cruiser, *the Derrflinger,* fired what is believed to be over 700 shells into the town although the exact figure is disputed. A maid, a shoemaker, a postman, a boy scout, a mother and her children were amongst the killed. 18 died in all at Scarborough and many homes and hotels were damaged. Panic caused people to flee. During the raid, 150 mines were also laid to destroy any Royal Navy ships that might come to intervene. The mines later sank several fishing boats and caused more deaths than the shelling. During the war, U-boats were attacking and sinking fishing and merchant vessels to try and starve England into surrender. On 4th September 1917, a 'second bombardment' took place when a 'U' boat surfaced in the South Bay and fired 30 shells at the town killing three people.

5. Scarborough Harbour and Fishing Fleet

Fig 28: The fishing industry almost closed down during the war and many boats moved north to Aberdeen, closer to the large British naval bases and their protection. So destructive were the mines to the fishing boats that the industry never fully recovered its pre-war levels of activity and as late as 1920 a mine sunk the fishing vessel the *'Jack Johnstone'* killing all 10 of the crew.

5. SCARBOROUGH HARBOUR AND FISHING FLEET

Leaving Eastborough, the trail drops down to the Foreshore where a visit to the harbour walls and lighthouse is of interest. World War I enemy U-Boats sank 75 fishing vessels off the coast and many involved the Scarborough fishing fleet, which was effectively wiped out. 98 men died in these losses and formed part of Owen's writing about the 'futility of war'. Owen would have seen the shell damage to the lighthouse from the 1914 bombardment, which was only repaired long after the war. The fishing fleet continued to lose men to warfare as long as 1920 when a mine sank the 'Jack Johnson' off the Scarborough coast, killing all 10 of the crew.

In the harbour the working lighthouse guarding the shipping entrance to the town can still be seen. The lighthouse was badly damaged during the 1914 bombardment and was not repaired until many years after the war had ended. A plaque at the lighthouse marks the event and a defensive gun can still be seen on the pier side.

Today Scarborough is still a working fishing port with the added interest of several businesses including being a base for the service of wind farms in the North Sea, as well as a number of pleasure boat activities. After the First World War Scarborough became a major Tunny fishing locale with big game fishermen from all over the world coming for the sport. 'The Tunny Club' still remains near the harbour and is now a popular fish restaurant and café.

Fig 29: Scarborough Light-house showing 'Bombard-ment' damage.

6. Foreshore and The Spa

Fig 30: Owen would have known this beach front area from his visit here in 1905, aged 12. On his return as a soldier he seemed to have taken a poor view of those holidaymaking and war profiteering whilst he and his colleagues were laying down their lives. The foreshore is changed these days but older buildings from the period still survive and the location of the 1905 photograph can still be recognised. Owen would have walked this route on his many rambles and for the trail it links the Old Town part of the route with the South Cliff area. The Spa would probably have been of interest to

6. FORESHORE AND THE SPA

Leaving the harbour the trail follows the sea along South Bay to the Spa. Owen talks disparagingly about the profitieers and holiday makers in his letters to Susan his mother and had a poor view of those who sought to avoid service, whatever their beliefs.
It was here that Owen first came to Scarborough with his family as a boy and the seafront would have been very familiar to him during his wartime stay. The Spa is a great place for a stop along the trail for a coffee or a meal before moving on to the second half of the route.

FARRER'S
BAR · BRASSERIE · SEA VIEWS

Scarborough Spa, South Bay, YO11 2HD
01723 357860
Farrers.Brasserie@siv.org.uk

him, given it is such a famous part of Scarborough's rich and diverse history, and it is worth a visit in its own right. Farrer's Bar serves excellent light meals and drinks and there is a wide range of entertainment available at the Spa Theatre and Ocean Rooms throughout the year.

7. Scarborough Art Gallery

Fig 31: Scarborough Art Gallery in The Crescent, part of the Scarborough Museums Trust, is an important stop on the Owen Trail. Here can be seen Owen's bust cast in bronze by the sculptor and artist, Anthony Padgett. The artist donated the bust, one of several he made for the different locations associated with Owen, to the town in 2016. In 2018 the Museums Trust staged a major Owen exhibition here to much popular acclaim, and Jennifer Dunne, the collections' curator, gave a number of excellent talks on Owen and the exhibition during that time. The Gallery charges a small annual fee (currently £3) for entrance and together with the Rotunda Museum nearby, also managed by the trust, is well worth exploring.

On the 99th anniversary of his death in 2017 Scarborough Museums Trust unveiled a bust of Wilfred Owen at Scarborough Art Gallery. The sculpture was accepted on behalf of the town as a very generous donation from the artist, Anthony Padgett. It is one of a series offered to various sites connected with the poet's life and death, including one at Craiglockhart Hospital in Edinburgh, where he recuperated from 'shell shock' and met Siegfried Sassoon, and Ors in France, his final resting place. An unveiling and illustrated lecture took place in

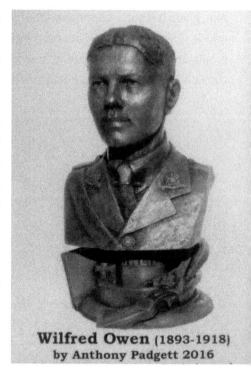

Wilfred Owen (1893-1918)
by Anthony Padgett 2016

Fig 32: A postcard showing the bust of Wilfred Owen by Anthony Padgett (2016)

the art gallery with a selection of Owen's poems being read by local actors, Felix Hodcroft, Heather Stoney and the author together with a performance of Owen's *'The Letter'* by Anthony Padgett himself.

Jennifer Dunne of Scarborough Museums Trust writes;

'Wilfred Owen's connection with Scarborough is an important one both for the town and for his development as a poet. He wrote, rewrote and drafted many poems while here and received advice and constructive criticism from friends such as Siegfried Sassoon and Robert Graves.

Owen arrived in Scarborough in November 1917 as an officer with the Manchester Regiment and was billeted at the Clarence Gardens Hotel, now known as the Clifton Hotel, North Bay. He stayed there until March 1918 and then returned to the area in June of the same year to prepare for redeployment to France. During the second visit he was based at Burniston Barracks, which once stood on Burniston Road but has now been replaced by a modern housing estate.

Consequently, in the final year of his life, Owen spent a significant amount of time in Scarborough, on active service, even though he was almost certainly still suffering from Post-Traumatic Stress Disorder (PTSD). It had not been the practice to send men suffering from 'shell shock' back to the Front but after a German counter-offensive in 1918 the British Forces were in desperate need of men on the ground, so soldiers like Wilfred were redeployed.

Disgust at the futility of the war and the tremendous loss of life is conveyed through Owen's poems but there is also a great empathy for the men he led and served alongside.'

(With thanks to the Scarborough News where a version of this article first appeared.)

Fig 33: The artist Anthony Padgett with his bust of Wilfred Owen.

Fig 33a and b: Two of the panels at the Wilfred Owen Memorial Exhibition at the Scarborough Art Gallery 2018.
(Used by kind permission of Andrew Clay, CEO Scarborough Museums Trust)

8. Woodend and The Crescent

8. WOODEND AND THE CRESCENT

Next door to the Art Gallery is Woodend, the former home of The Sitwell Family. The building now houses a range of creative businesses together with an art gallery and small art and craft shop. The Sitwells feature largely in the Owen story in that after Owen's death, Edith, a leading literary light of the time was largely responsible, along with Siegfried Sassoon, for the publication and promotion of Owen's poetry. Osbert Sitwell enjoyed a close, if short lived, friendship with Owen. On leaving Woodend, follow the Crescent where you can still clearly see many shell scars of the 1914 bombardment. At the end of The Crescent turn left and left again into Somerset Terrace. Walk up the short hill to the junction with Valley Bridge Road.

woodend

www.woodendcreative.co.uk

Fig 34: Woodend, a Grade II listed building dating from 1835, is an important creative centre located in Scarborough's genteel Crescent and forms part of what is known by many as Scarborough's 'Cultural Quarter'. It is important in the Owen story as it was the home of the famous literary family, the Sitwells; Edith, Sacheverall and Osbert. Owen was introduced to Osbert in London through Siegfried Sassoon and Edith Sitwell was instrumental in promoting and publishing the recently deceased Owen after the war. Woodend hosts many creative arts events, has its own art gallery and hosts an excellent coffee lounge, 'Yay Coffee'. The Crescent received direct hits during 'The Bombardment' and shell scarring can still be seen on many of the buildings. Woodend is a must for anyone interested in the arts generally as well as anyone looking for the ideal coffee spot.

Fig 35: 'Woodend', the former home of the literary Sitwell family is now a very successful and innovative creative arts centre.

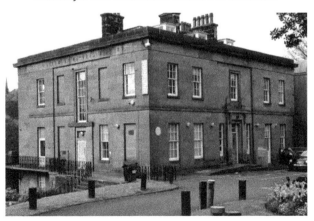

Edith Louisa Sitwell was born at Woodend on 7th September 1887 and was the only daughter of Sir George and Lady Ida Sitwell (*nee* Dennison). In 1954 she was made a dame and died on the 9th December 1964 in Northamptonshire. Edith Sitwell published poetry continuously from 1913 and was part of the 'Bloomsbury Set' of the 1930's literary world. She is best known for her collaborative work with William Walton on the poem *'Façade'*. She was the first to publish Owen, posthumously, in her anthology magazine *'Wheels'* from 1919 and is credited with bringing him to prominence.

Author John Pearson commenting on Osbert Sitwell, one of Scarborough's most famous literary icons on be-friending Wilfred Owen;

'Osbert found him shy, younger looking than his age – he was twenty – four – but with the 'easy supple good manners of the sensitive'...their opposition to the war was, Osbert wrote, like the 'force with which faith had knitted together the early Christians', and they began exchanging poems as they wrote them. It was one of Osbert's...which brought back in reply one of the most moving letters Owen ever wrote:

'For 14 hours yesterday I was at work-teaching Christ to lift his cross by numbers, and how to adjust his crown; and not to imagine he thirst until after the last halt; I attended his Supper to see that there were no complaints; and inspected his feet that they should be worthy of the nails. I see to it that he is dumb and stands to attention before his accusers. With a piece of silver I buy him every day, and with maps I make him familiar with the topography of Golgotha.'

It was in the summer of 1918 that Osbert saw the last of Owen... en route for France. It was a fine, hot summer day. Sassoon was back, and he and Osbert met Owen and took him to hear their friend Violet Gordon Woodhouse play the clavichord making 'the afternoon stand out as an oasis in the desert of war'. Afterwards the three

poets had raspberries and cream at Swan Walk, and then sat for a while beneath the mulberry trees in the Physic Garden before Owen left to catch his train. On 4th November he was killed in action; a week before the war ended.'

Extract from 'Facades: Edith, Osbert and Sacheverell Sitwell' by John Pearson 1978

In his own book *'Noble Essences'* Osbert Sitwell dedicates a complete chapter (Chapter 4) to Owen who had made a profound effect upon him. A copy of this work and many others by the Sitwells can be viewed at Woodend by courtesy of the custodians of the Sitwell collection, the Scarborough Museums Trust.

Fig 36: Book cover 'Facades: Edith, Osbert and Sacheverell Sitwell' by John Pearson.

9. Pavilion Square and The Railway Station

Fig 37: Pavilion Square features in the Owen Trail because the poet must have attended here many times when he took German lessons from his cousin, May Susan Davies. The square on two sides is much as Owen would have seen it although the third side was re-built in the 1970s and replaced with an unsympathetic concrete and glass office structure.

Across the road from Pavilion Square is Scarborough's main railway station; the place Owen arrived at in the late evening of November 1917 having been unable to find accommodation in York. He put up at The Victoria Hotel opposite the station. The station is notable for having the longest continuous platform seat in the country as well as frequently hosting steam and vintage diesel train excursions. It is possible to spot *'The Flying Scotsman'* here from time to time when it is housed overnight during the excursion season. The station is still busy throughout the year serving the York-Manchester-Liverpool route to the west and Hull to the south. In its heyday hundreds of thousands of holidaymakers and works trips would arrive for their short breaks at Scarborough station.

9. PAVILION SQUARE AND THE RAILWAY STATION

At Valley Bridge Road, turn right and there you will see Pavilion Square, where Owen's 'Cousin' May Susan Davies lived and which would have been very familiar to him as he took German lessons there. Crossing the road walk up to the next junction and turn left into the Railway Station, a Grade II listed building. This is where Owen first arrived in Scarborough and amongst its features is the world's longest platform bench at 85 metres. In its heyday, thousands of passengers would arrive at the station on day trips from the West Riding and elsewhere and it remains a busy station to this day.

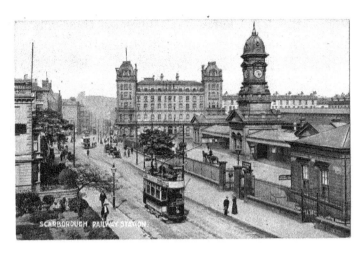

Fig 38: Contemporary postcard showing the railway station as Owen might have seen it.

10. The Victoria Hotel ('The Old Vic')

10. THE VICTORIA HOTEL ('OLD VIC')

Almost opposite the railway station is the 'Old Vic' a well known Scarborough hostelry where the newly arrived Owen spent his first night in the town. The pub is best known as the possible birthplace of Charles Laughton, but it is possible Owen may have talked with Laughton's parents as the young Charles was also serving in the army at the time. The pub stages events and the Scarborough Poetry Workshop has performed some of Owen's works here.

The Old Victoria Hotel - 79 Westborough, Scarborough, North Yorkshire, YO11 1TP
http://www.thevictoriahotel.biz/

Fig 39: Owen arrived in Scarborough by train in November 1917 and spent his first night at the Victoria Hotel, then being run by the Laughton family. Owen sent a postcard to his mother from the hotel informing her that he would shortly be moving to the Clarence Gardens Hotel. Charles Laughton, the son of the household

59

was serving in the war. Charles later went onto become one of the leading actors of his day, being knighted for his services to the theatre. His association with Scarborough was recently commemorated by local author and playwright, Roger Osbourn in his play *'Laughton'* which opened at Scarborough's Stephen Joseph Theatre. Sadly, at the time of publication, the hotel had closed after some years of declining business and its future is uncertain but at one time it staged many performances of the Scarborough Poetry Workshop including recitals of Owen's work.

11. Dean Road Cemetery

11. DEAN ROAD CEMETERY

From the 'Old Vic' return to the junction by the Stephen Joseph Theatre and follow Northway for 500 yards until it becomes Columbus Ravine. 400 Yards on your left hand side you will see the east entrance to Dean Road and Manor Road Cemetery. Owen would have known this historic area, perhaps basing some of his poems on the inspiration he received here. Over 300 people who died on active service in WW1 are remembered here as well as a number of civilians killed during the bombardment of Scarborough. The cemetery is well worth a good look. Look out for the Secret Garden and Bombardment Cairn.

A separate trail is available from:
https://www.scarboroughcemeteries.co.uk

Fig 40: Dean Road Cemetery is included in the trail because Owen must have walked through this area on his many rambles about Scarborough. There is a possibility that Owen based some of his writing on the experience he had during these walks. In the cemetery the graves and memorials of many victims of the First World War can be found including those of the victims of 'The Bombardment'. Much dedicated restoration work has been completed by the Friends of Dean Road Cemetery over recent years including the erection of an impressive cairn in their memory.

12. The Northern Cavalry Barracks

Fig 41: There is little left to see now of the old barracks, usually known as 'Burniston Barracks', which were demolished a few years ago to make way for a new private housing estate. But it was here that Owen lived in a 'dusty old tent' by the barrack gates on his second spell at Scarborough in 1918. At the northern end of the old barracks site, a 'pill box' can still be seen and the estate location is now marked for posterity by the names of the various roads commemorating several of the units that were quartered there. Len Friskney, who has written the first two chapters of this work, was himself stationed there as a corporal in the Green Howard's Territorial Army and Volunteer Reserve Unit.

12. NORTHERN CAVALRY BARRACKS BURNISTON ROAD

Owen was posted back to Scarborough on the 5th of June 1918 as an officer the 5th (Reserve) Battalion of the Manchester Regiment, and lived in a tent in what is often known as the Burniston Barracks. The site is now a modern housing estate and all that remains from this time are street names of regiments that served here. For a most enjoyable woodland walk it is possible to follow the trail that Owen would probably have taken many times during his stay in Scarborough. From the west entrance walk under the bridge and follow the marked path through Peasholm Glen and Park to Burniston Road. To see the site follow Burniston Road for around a mile and the area stars were the Alpamare Waterpark and Tunny Catch pub are now situated.

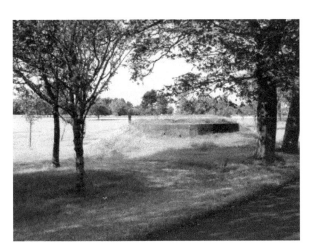

Fig 42: An image of the Northern Cavalry Barracks ('Burniston Barracks') in 2018 from the illustrated launch lecture of the Owen Map and Trail, Newby and Scalby Library 2018.

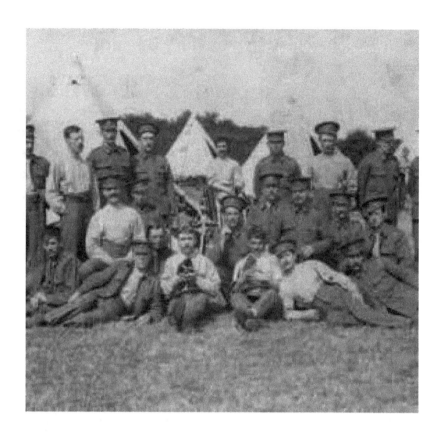

Fig 43: Image of the tented camp at Burniston Barracks as Owen would have experienced it on his return to Scarborough in 1918.

Chapter 4:

Scarborough and the First World War

In this chapter, aspects of the First World War in Scarborough are described as they relate to the *'One Day in December'* story. These are told through the words of a number of commentators, both contemporary and modern, or through reminiscence, newspaper commentary and diary or letter extracts. A much more comprehensive work is needed concerning the general effect of the war on the people of Scarborough and it is hoped that members of the Scarborough Maritime Heritage Centre may well undertake to fill this need in due course.

Amongst these extracts I acknowledge both the comprehensive work, *'Bombardment'* by Scarborough based author, Mark Marsay, and the help of Mark Vesey and Stewart MacDonald of the Maritime Heritage Centre. The history of the war as it is described here through a number of individual commentaries is included in this work to show how the community groups involved in the Community Theatre Production, *'One Day in December',* undertook their research in order to write and perform their own sketches; essential learning elements of the whole concept.

The descriptions included are by no means meant to make light of any of the events that took place anywhere else on the coast from Hartlepool to Great Yarmouth during the war but these extracts are included because they form the basis of the book's central purpose; the community theatre and the research completed by the young people who took part.

Fig 44: Owen mentions frequenting an Oyster Bar in Scarborough in letters to his mother; possibly 'Tidmans'.

'The Bombardment of Scarborough'

by Mark Marsay

'It was with horror that Scarborough, undefended by so much as a single shore battery, awoke on the morning of Wednesday, 16th December 1914; the entire population startled into wakefulness by a sudden and unexpected cacophony of noise – the bombardment levelled on it by two German warships.

Earlier that morning the enemy battle-cruisers *Derfflinger* and *Von der Tann*, and the triple funnelled light cruiser *Kolberg,* had peeled off from Admiral Hipper's First Scouting Group (comprising five battle cruisers, with supporting light cruisers and destroyers) under the command of Rear-Admiral Tapken, and had crept up to the north-east coast in the early dark hours. As dawn approached, the trio of vessels remained cloaked from detection by a hell-sent rolling bank of early morning mist – 'typical to this coast.'

Like harbingers of doom the three battleships, hulking masses of cold grey steel silhouetted against the grey of the early morning mist, steamed southward, a mile off shore and parallel to it. As the bow of the leading vessel pierced the cloak of invisibility unwittingly supplied by mother nature, its captain raised his field glasses and surveyed the scenic tranquillity of the town's dual bays.

On the dew-damp cliffs north of the town, at Hayburn Wyke, the attention of three workmen engaged on repairing a cottage – Tom Nellist and brothers, David and Thomas Coultas – was caught by the movement of the three warships; two extraordinary large vessels and one much smaller. The men were struck by the closeness of the vessels to the shore. As the light increased the ships were seen to move southward towards the town, the smaller one leading the way. The speed of the ships gradually increased and with it the smoke from their funnels changed from grey to black, a dense heavy cloud left in their wake.

Nothing stood between the enemy and the coast, not so much as a fishing coble with a pistol on board.

As the *Kolberg* steamed on ahead, towards Filey and Flamborough head to lay a deadly carpet of mines for any Royal Navy vessel which might come in pursuit, aboard the *Von der Tann*, Captain Hahn, satisfied all was well, lowered his field glasses, turned slightly, received a curt nod from Rear-Admiral Tapken and barked an order to his battle-ready gun crews;

"Feuer Geben!"

The giant 11-inch naval guns opened fire with a thunderous broadside, swiftly echoed by her 5.9-inch guns.

Several hundred yards away Captain von Reuter, on the bridge of the *Derfflinger,* gave the same order and her 12-inch gun barrels erupted in gouts of angry crimson flame, quickly followed by a succession of salvos from her 5.9-inch guns.

The time was eight o'clock, and all the fury of hell had been loosed on the gently slumbering 'Queen of the Yorkshire Coast'.

The Enemy's First Pass – Southward

Those townsfolk already awake, at breakfast or dressing, rushed to their windows and doors believing the worst thunderstorm in living memory was being visited on the town. Those in bed started into wakefulness and stumbled to their windows to discover the cause of the unbelievable noise. In streets and lanes folk going about their normal daily routine stopped where they were, rooted to the spot, as shells whistled and whined overhead. Horses, harnessed into drays, whinnied and shied nervously, nostrils flared, ears pricked back, their eyes wide with fear and mounting panic as the first shells smashed into buildings and roads, belching smoke, flames and debris high into the air.

There followed but a brief moment of silence, a lull, a pause after the first round of shells, while the enemy reloaded their great naval guns. Then the air was again hot with whistling, exploding shells, flying shell fragments and shrapnel. The town was filled with the cacophony of bursting shells, falling masonry, breaking glass, splintering wood and shattering slates.

The Enemy's Second Pass – Northward

As the D*erfflinger* and the *Von der Tann* levelled with White Nab (close to Cornelian Bay), they veered away, turned and began to retrace their steps, all the while maintaining their rate of fire. Meanwhile the *Kolberg* continued south-east, laying a screen of over a hundred mines to parry any attempt by the Humber and Harwich Royal Naval flotillas to intervene, should they try. The concentration of mines laid by the Kolberg was heavy to say the least, and many of the mines discovered many years later come from the 'Kolberg Minefield'. They were to continue claiming many more lives long after the raid was over.

At Cayton Bay, the Yorkshire Hussars were on the alert guarding the Scarborough Waterworks Pumping Station, assuming a landing on the beach following a salvo of twenty rounds aimed at putting it out of action. As they manned their trenches and machine gun pits, Scarborough's usually placid and peaceful streets, its tree-lined avenues and leafy lanes, had become places of terror, injury and death. Each battleship now altered the elevation of its guns and deliberately targeted different areas of the town. The bombardment suffered so far was nothing compared to the shells that now fell. Steel, shell, high explosive and shrapnel rained down from the skies over the most populated parts of the town and there was practically no escaping it as the place was swept from sandy coast to borough boundary by withering fusillade after withering fusillade.

Had the local populace stayed within their homes it is possible fewer would have suffered injury. As it was frightened, bewildered and anxious to be away

from the shelling, hundreds dashed into the streets where they were caught by flying shrapnel, glass and falling building debris.

The Aftermath

The town's ordeal had lasted for just twenty-five minutes, but by the time the German battleships had left the place was in uproar and panic; some seventeen people lay dead, among them women and children, and more than 80 had been injured. Many more were suffering from shock. When the final death-roll was called the total would number 18.

The last time Scarborough had heard the angry retort of naval guns was in September 1779 when American Paul Jones captured two British warships within sight of the town after a fierce engagement. Wednesday 16th December 1914 had seen a new and frightening page written in the town's history.'

'The Wireless Station'

by Mark Marsay

'Throughout the war, the Wireless Station, Scarborough's only genuine 'military' target, was situated behind Falsgrave Park and was under the command of Chief Officer Dean of the Coastguard. The station was manned twenty-four hours of the day, every day of the year and was used to listen to enemy ship-to-ship radio signals which were then used to fix the positions of the enemy ships whilst at sea ... the Germans, evidently intent on destroying it sent over a large number of shells but all bar one fell short.

The men on guard duty and those working at the station sensing the danger they were in retired some hundred or so yards to the rear of the station

and were safe, meanwhile the stations guard dog and mascot 'Bob', a little wire haired terrier, had decided to abandon his post too and he shot off as fast as his four paws would carry him. He was eventually found on the race-course well away from the Wireless Station.

'Another Death on Albion Street'

(The Death of Boy Scout George Harland Taylor)

by Mark Marsay

'Fifteen-year-old George had left his home at 45 North Street whilst the bombardment was in progress, despite his father John's attempts to stop him, to fetch the local newspaper (The Scarborough Pictorial) which was run-ning a story and photograph of him. Having collected the paper, he had been hurrying along Albion Street on the way to a chum's house, when he was struck in the back by a piece of shell. James Normandale, who had been working in Castle House's garage close by, looked up as George cried out in pain, saw the boy stagger and fall, and rushed to his aid. When he reached him, the boy was still alive, through struggling to breathe.

Carefully, James slid his arms under the boy and carried him into a nearby house where a doctor was at once sent for. James then searched the boy's pockets for some sign of his identity and discovered the newspaper and a postcard. With George growing weaker by the second, James then rushed through the town to the boy's home to acquaint his mother, but by the time he returned with the boy's frantic parents, George had died from his injuries.'

'Remember Scarborough!'

by Esther Graham, Scarborough Museums Trust

Fig 45:'Remember Scarborough!' by Edith Kemp-Welch. Oil on canvas. (Photograph used with the permission of Scarborough and District Borough Council).

On December 16th 1914, German battle cruisers fired hundreds of shells on Scarborough, Whitby and Hartlepool; an offensive which became known as 'The Bombardment'. Many died, 18 in Scarborough alone, and many more were injured. Many buildings and homes were destroyed. This attack caused great public outcry and 'Remember Scarborough!' became the slogan for an impassioned recruitment drive across the nation.

'The Bombardment' was a significant moment early in the war, a major event played out on a very local stage; the scars of which can still be seen on buildings around Scarborough and in the memories passed down from one generation to another. It is important for this present generation, and future ones, to have an understanding of Scarborough's place in the war and the community spirit which prevailed to bring the town from the brink of devastation back to the seaside resort of fame.

The photograph shows *'Remember Scarborough'* by Edith Kemp-Welch painted in 1915 in oil on canvas. It was later donated by the artist to Scarborough where it still hangs in the Town Hall. This was the image used by the authorities nationally to galvanise public opinion through a wave of national indignation. It is credited with persuading thousands of young men and women to offer their services to the country either as soldiers, sailors or airmen or as nurses and munitions workers and it is an image that became world famous.

'Westborough Chapel in the First World War'

by Joan Bayes

Westborough Wesleyan Methodist Chapel, as it was originally called, is situated in Falsgrave Road, Scarborough and was opened on 4th April 1862. As the First World War started the chapel had been in operation at the heart of the community for over 50 years.

During the war, the chapel's basement was used as a troops' canteen and the schoolroom as a Red Cross Hospital. Henry Harland of 8, Belle Vue Street, was a shoemaker and cobbler who worked nearby at Alma Parade. As the bombardment started, he rushed home from the shop to help his wife and children and was with them when he was hit in the back by a piece of shrapnel. He was taken to the Westborough Schoolroom hospital where he died on 26th December 1914, the last, and sometimes unlisted, of the 18 people who died as a result of the bombardment in Scarborough.

As a result of the likelihood of both invasion and further bombardment the church elders felt it prudent to take out insurance which thankfully wasn't to be claimed upon, the church remaining undamaged throughout the war, including the second bombardment, this time by a 'U' boat later in the war.

On the Sunday following the 1914 'Bombardment', the Reverend John Gould (Superintendent Minister) was the preacher, intending to deliver his homily on 'Thou shalt not kill.' As a result of the action he changed the text to 'The Gospel of Love.' It is possible to imagine that the feeling was one of anger and revenge throughout the town and no doubt the minister felt it more appropriate to try and calm these feelings as well as to offer a sense of hope to the families who had been bereaved.

This is an extract from a letter written by local resident Gertrude Harrison, aged 27, to a cousin in Canada on the 30th December 1914.

'The basement of Westborough Wesleyan Chapel (our chapel) has been taken as the 2nd Military Naval Base Hospital. It is used for east coast camps. A number of people wounded in the bombardment were also taken there. The members of the local Red Cross and St John Ambulance nursing corps take alternate duty there. I am a member of the latter, but have not been to nurse there yet, having only just got my uniform. We started to work for our exams as soon as war broke out. The students in Darlington College are all working for the Red Cross exams. In fact, almost every other woman here is taking up either one or the other.'

(Used with kind permission of The Northern Echo; www.thenorthernecho.co.uk)

'An Uninterrupted Wedding'

*by Mike Bortoft**

At 8 o'clock on the morning of 16th December 1914, Holy Communion was taking place at St Martin's on the Hill Church on Scarborough's South Cliff. Two shells struck, the first crashing through the roof towards the rear of the church and the second hitting the east wall and damaging the brick-work. Amongst the congregation that morning was Winnifred Louise Duthoit, a 21-year-old housekeeper living at 27, Prince of Wales Terrace, who, later that day, was due to marry Richard Garton Horsley, a 21-year-old trainee architect from Cromwell Road, Scarborough. Despite the trauma of the bombardment the vicar decided the wedding should still go ahead and the couple were married as planned. The newly-wed wife kept a piece of the shrapnel as a token of that momentous day and the couple left for their honeymoon on a motorbike and sidecar. They later recalled the problem they had making their way through crowds trying to flee Scarborough in case of further shelling or even invasion. Evidence of the shelling can still be seen in the church today.

Later that week Archdeacon Mackarness received a letter of support from the Archbishop of York, Cosmo Gordon Lang, which was duly read out to the congregation and which included these words:

My dear people,

You have lived through a memorable and terrible experience. Let me send a message of heartfelt sympathy to those whose nearest and dearest have been so suddenly and cruelly killed; to those who have themselves been hurt; to those whose homes have been shattered, and to you whose churches have been damaged. Our hearts burn with just indignation at this wanton onslaught on a practically defenceless town and its peaceable people; at

this cruel breach of law by which civilised nations have agreed to restrain the horrors of war.

Let us sternly set ourselves to defeat its object. If the object was to create a general panic and alarm, you who have quietly stayed at home have already proved its banality. |If the object was to hinder the discharge of fresh reinforcements to the battle line in France and Flanders I am sure that the men of our county and country will make it futile by enlisting in even larger numbers, so that for every man who is sent abroad, another will be ready to take his place and defend our land.

The ordeal through which you have passed will not have been suffered in vain, if it brings home to all of us the nature of that ruthless war spirit which we and our lives are called upon for the sake of the world's peace to destroy, and that it leads us with deeper earnestness to turn to God and to commit ourselves and our cause to Him. It was given to you, dear vicar of St Martin's, and to some of your people to teach us all a lesson we shall never forget.

I heard with pride and thankfulness of the calmness with which you refused to allow the celebration of the Holy Communion to be interrupted by the noise of the guns or the bursting of the shells. 'You realise that God is in the midst of His Church therefore shall He not be removed'.

Later the BBC recorded Richard Horsely talking about the experience and that reminiscence can be heard in their archives and on the church website. As well as being an active centre of Christian faith and worship, the building itself is full of interesting historical legacy with strong connections to the Pre-Raphaelite artistic movement.

Fig 45a: Winifred Horsely and her young family. Fig 45b: St Martin's Church showing the shell sites.

*Mike Bortoft is a local historian and a member of the Friends of St Martin's Church. Extract and photographs used with permission.

'The Protagonists'

by Mark Vesey

For the people of England, the 'Bombardment of Scarborough' was the first direct taste of the greatest war of all time. By December 1914, few direct reports had come back from France of the true horrors of trench warfare. The papers were still full of naive nationalism. The war was expected to be over by Christmas. Perhaps in a small way Scarborough did have a real taste of this war. According to a legend a parrot kept at the Sandside Mission for Seamen talked vigorously until the day of the bombardment. It never spoke again. Perhaps this parrot was Scarborough's first victim of shellshock.

The *'Derrflinger'*

The **SMS** *Derfflinger,* the ship which bombarded Scarborough, was a battle cruiser of the German Kaiserliche Marine built just before the outbreak of the war. She was the lead vessel of her class of three sister ships with the *Lutzow* and the *Hindenburg.* The ship was named after Field Marshal Georg von Derfflinger who fought in the Thirty Years' War.

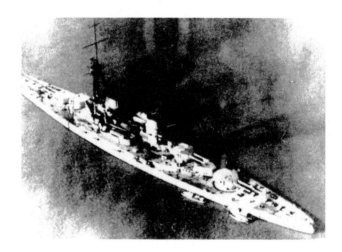

Fig 46: The German battle cruiser Derfflinger. (Photograph courtesy of the Cuxhaven Naval Museum and Len Friskney)

The *Derfflinger* was part of the German First Scouting Group for most of World War I, and was involved in several fleet actions during the war. She took part in the bombardment as well as the Battles of Dogger Bank and Jutland, where her stubborn resistance led to the British nicknaming her the "Iron Dog". The ship was partially responsible for the sinking of two British battle cruisers at Jutland; HMS *Queen Mary* and HMS *Invincible*. *Derfflinger* was interned with the rest of the High Seas fleet at Scapa Flow following the armistice in November 1918. Under the orders of Rear Admiral Ludwig von Reuter, the interned ships were scuttled there on 21 June 1919 ,the *Derrflinger's* ship's bell later being salvaged and placed on the Island of Eriskey.

The '*Von der Tann*'

Flagship of Rear Admiral Tapken, the *Von der Tann* was Germany's first large warship driven by turbine. The battle cruiser was completed in 1910 having been launched at the Blohm and Voss Shipyard, Hamburg in 1909. The captain was Kapitan zur See Hahn and she had a crew of 1300. The principal armament was 8 x 11-inch guns and 10 x 5.9-inch guns. Her gross tonnage was 19,100 tons.

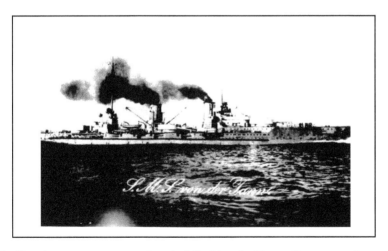

Fig 47: A contemporary postcard of the Von der Tann. (Image courtesy of the Cuxhaven Naval Museum and Len Friskney)

Although accounts vary, it is believed from German records that over 700 shells were fired at Scarborough with a counted 487 being direct hits. The following 17 people lost their lives that day and one later as a result of his injuries and there was extensive damage.

Leonard Ellis, (47)	Back Londesborough Road.
Harry Frith (45),	1 Bedford Street.
Alfred Beal(41)	50 Raleigh Street.
Margaret Briggs (30)	31 Filey Road.
John Shields Ryalls (14 Months)	22 Westbourne Park.
Miss Bertha McIntyre (42)	22 Westbourne Park.
Mrs Johanna Bennett (58)	2 Wykeham Street.
Albert Featherstone Bennett (22)	2 Wykeham Street.
John Christopher H Ward (10)	2 Wykeham Street.
George James Barnes (5)	2 Wykeham Street.
John Hall (65)	28 Westbourne Park.
Mrs Emily Lois Merryweather (30)	43 Prospect Road.
George Harland Taylor (15)	45 North Street.
Mrs Mary Prew (65)	17a Belle Vue Street.
Mrs Ada Crow (28)	124 Falsgrave Road.
Miss Edith Crosby (39)	1 Belvedere Road.
Mrs Alice Duffield (56)	38, Esplanade.

Henry Harland (30), 8 Belle Vue Road, (died in Westborough Chapel's schoolroom on 26th December 1914 as a result of injuries received during 'The Bombardment').

The story of the boy scout who died, George Harland Taylor, is the subject of one of the sketches in the community theatre production of 'One Day in December ('The Lost Scout') researched, written and performed by members of today's scouting movement, a testimony to the organization's

steadfastness of purpose in peace and war. The death of Alfred Beal is also referred to within the script as is the hospital in the sketch 'Remember Scarborough.'

Fig 48: The bell of the Derrflinger which now hangs on the island of Eriskey.

Gallery: Bombardment Damage in Scarborough 16th December 1914

The following photogaphic images have been kindly supplied by the Scarborough Maritime Heritage Centre who hold a more extensive collection of images relating to 'The Bombardment'. Many, if not most of the contemporary existing images relating to the events of December 1914 also appear in the book *'Bombardment; The Day the East Coast Bled'* by Mark Marsay and published by the Great Northern Press in 1999. A few from the Maritime Centre are reproduced here by way of showing the background to the *'One Day in December'* story.

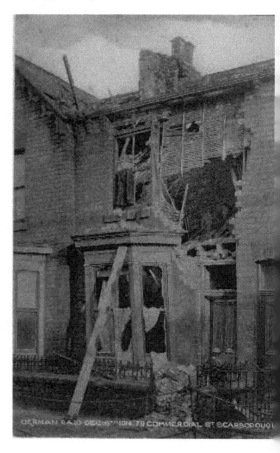

Fig 49: A house in Belvoir Terrace where a shell entered through the upstairs window causing extensive damage throughout the house. The postcard reads that an 'Old lady had a miraculous escape'.

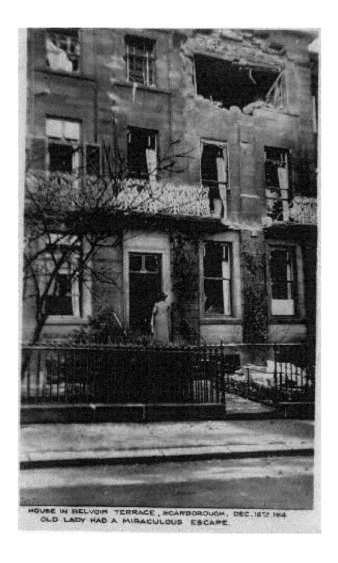

HOUSE IN RELVOIR TERRACE, SCARBOROUGH, DEC. 16TH 1914
OLD LADY HAD A MIRACULOUS ESCAPE

Fig 50: Shell damage in terraced housing in Commercial Street.

Although it seems intrusive today, at the time it was common practice to produce and sell post cards of traumatic events, particularly disasters, and this may have been influenced by the scarcity of available media for transmitting such images to the populace in the pre-television era.

81

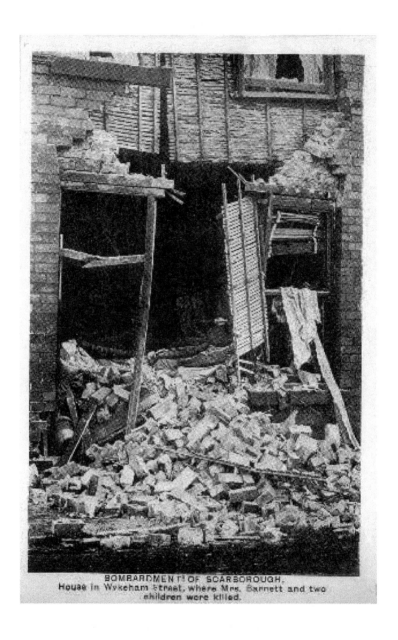

BOMBARDMENT OF SCARBOROUGH.
House in Wykeham Street, where Mrs. Bennett and two
children were killed.

Fig 51: The house at 2, Wykeham Street where Johanna Bennett, aged 58, Albert Bennet, aged 22, John Christopher H. Ward, aged 10 and George James Barnes, aged 5, lost their lives.

'After the Bombardment' *by Lynne Read*

'On the surface the town was getting back to normal after the trauma of the bombardment and the celebration of Christmas. The debris was slowly being cleared, but many people were still homeless. Friends and relatives took in some until their own homes were habitable again or until they could find somewhere else to live. Others were in temporary, makeshift accommodation until the town council could re-house them. The propaganda posters and the sense of outrage had been instrumental in creating an upsurge of young men patriotically volunteering to join the army and the navy, much to the distress of their wives and mothers.

Those who lived through that day in December 1914 always remembered; it changed the lives of so many people...'Iris' lived on until her mid-nineties; she became very confused in her later years and forgot many things, but the events of the bombardment remained forever clear in her mind.

The New Year would soon begin, it should have brought new hope, but instead it brought more horror, more sorrow, and more distress as the 'war to end all wars' progressed.

Many decades after the bombardment a publication by the Imperial War Museum showed that the bombardments of Scarborough, Whitby and Hartlepool could have been avoided. The Admiralty discovered on December 14th 1914 that a German cruiser squadron was set to sail early the following morning, Tuesday 15th December returning in the evening of December 16th. An Admiralty signal to Admiral Sir John Jellicoe, Commander of the fleet said: "The enemy will have time to reach our coast. Send at once, leaving tonight, the battler cruiser squadron and light squadron supported by a battle squadron. At dawn on Wednesday (16th December) they should be at some point where they can intercept the enemy."

The gamble failed. The Admiralty's priority was to annihilate the attacker on their return rather than prevent the attacks on Scarborough, Whitby and Hartlepool. A series of blunders and a change for the worse in the weather enabled the German warships to escape.

First Sea Lord Fisher and Admiral Jellicoe were furious. It took a while for the Admiralty to get their revenge. The *Von der Tann* and the *Derfflinger* were damaged at the Battle of Jutland by the Royal Navy in 1916 and were finally scuttled by their own crews at Scapa Flow in May 1919 in protest at the Versailles peace agreement.

Admiral Jellicoe was granted honorary freedom of Scarborough in May 1928. In a speech in the Council Chamber he blamed the bad weather for hampering the Royal Navy's mission without referring to the prior knowledge of the attack. If this prior knowledge been acted on over 120 lives could have been saved.'

(Lynne Read was a member of the Westborough Methodist Church congregation at the time of the first production of 'One Day in December' and in 2005 she published a fictionalised narrative account of The Bombardment called 'Thunder in the Morning'. Several of the young people in the community production used this story to produce their own sketches. This article is reproduced from the original programme.

'Wilfred Owen and Scarborough'

by the author

In many of the books about Owen, his relationship with the town of Scarborough is commented upon together with the influence of the town on his poetry. Some of the very best of his work was written here so the

influence was probably profound. From his almost daily letters to his mother, Susan, we hear how he seems to have walked about a lot in the town, visited bars, oyster houses, the theatre, cafes and furniture showrooms and played cricket in what was, and still is, a major English cricketing venue, the ground at North Marine Road, only yards from the Clifton Hotel being much loved by players and supporters alike. Owen is reported to have played cricket with his fellows whilst in Scarborough and appears to have shown some aptitude for the game.

It is beyond the scope of this work to detail the many references and conjectures but Guy Cuthbertson in his work *'Wilfred Owen'* (2014) says this about Owen and Scarborough;

> *'Owen developed his own sad seaside life in Scarborough, where his fellow officers, who were unhappy with his cold aloofness, called him 'the ghost'. One fellow officer, H.R. Bate remembered Owen at Scarborough suffering from 'colossal conceit or pathological shyness', self-enclosed, silent and solemn: he deliberately shunned all contact with his comrades'.*

Cuthbertson goes on to describe Owen's view from the 'Turret Room' as a view:

> *'...that could easily compete with the view of the cathedral in Bordeaux, or of the mountains in the Pyrenees. In one direction the verdant coastline, which included the terraced Clarence Gardens, and straight in front of his room was the sea, which, even on the clearest days seemed to be endless...using the sea he announced that 'The tugs have left me; I feel the great swelling of the open sea taking my galleon.'*

Soon after arriving in the Turret Room, Owen wrote a poem very probably influenced by this view looking down on the bleak terracing of the hill on which the hotel stands;

The Show

My soul looked down from a vague height with Death,
As unremembering how I rose or why,
And saw a sad land, weak with sweats of dearth,
Grey, cratered like the moon with hollow woe,
And fitted with great pocks and scabs of plagues.

Across its beard, that horror of harsh wire,
There moved thin caterpillars, slowly uncoiled.
It seemed they pushed themselves to be as plugs
Of ditches, where they writhed and shrivelled, killed.

By them had slimy paths been trailed and scraped
Round myriad warts that might be little hills.

From gloom's last dregs these long-strung creatures crept,
And vanished out of dawn down hidden holes.

(And smell came up from those foul openings
As out of mouths, or deep wounds deepening.)

On dithering feet upgathered, more and more,
Brown strings towards strings of grey, with bristling spines,
All migrants from green fields, intent on mire.

Those that were grey, of more abundant spawns,
Ramped on the rest and ate them and were eaten.

I saw their bitten backs curve, loop, and straighten,
I watched those agonies curl, lift, and flatten.

Whereat, in terror what that sight might mean,
I reeled and shivered earthward like a feather.

And Death fell with me, like a deepening moan.
And He, picking a manner of worm, which half had hid
Its bruises in the earth, but crawled no further,
Showed me its feet, the feet of many men,
And the fresh-severed head of it, my head.

Cuthbertson comments on this but it is perhaps all too easy to try and spot local influences in the words Owen uses. We are all influenced to some degree by our surroundings and the horrors Owen witnessed at The Front are there to see in all their stark reality through many of his poems. Perhaps that is what we should be focused upon rather than his brief, but profound, sojourns in Scarborough, however interested and committed to his memory we have now become.

'The U Boat Attacks of 1916 – 1917'

by the author

It is hard now to imagine the sense of fear that the new weapons of war, the submarine, and the underwater mine, probably had on most of the maritime people involved in the First World War. Now, submarines are well known aspects of naval warfare, but in 1914 they were a relatively new and frightening concept, attacking as they did unseen and undetected from under the waves. The sinking of the Cunard passenger liner, *'Lusitania'*, on the 7th May 1915 with great loss of life, had been turned into a full-scale propaganda exercise by the allies which would have heightened the sense of fear and loathing of these under sea monsters in the minds of the British, and, most importantly for the propogandists, the American public. Mines were loathed by all who used the sea and they continued to take many lives well after the war had ended.

Scarborough in 1914 was a busy fishing port using long-lining, trawling and drift netting techniques and many of the traders and townspeople relied on the fishing fleet sailing out of the East Coast ports, including Scarborough, for their livelihood. Many subsidiary trades such as icemaking, coal supply and the butchers and grocers who provided the food for the crews were hard hit by the losses. Several of the Scarborough boats were operated by the 'Ramsdale Steam Trawling Company', owned by local man Dick Crawford, and the company was to suffer heavily throughout the war.

In 1915, four vessels were sunk by the new U-boats. On the 5th May the steam trawler *Sceptre* (*DE 10*) skippered by Jack Christian of 21, Sandside and owned by Jack Ellis, was sunk whilst on passage from Dundee to Scarborough. The next day, the 6th May, the *Merrie Islington* (*H 183*) from Hull, but crewed by Scarborough men, was sunk followed by Dick Crawford's *Condor* (*SH 12*) skippered by Robert Heritage, sunk by a mine on 29th May just north of Scarborough. The nine-man crew including the skipper were all lost. Finally, on the 9th June 1915 the trawler *James Leyman* (*SH 192*) was sunk by a U-boat.

Then, at about 5.30 pm on 1st July 1916, the fishing fleet was attacked again by a U-boat and the trawlers *Florence (SH 144)* skippered by Danny Crawford and *Dalhousie* (*SH 72*) skippered by Harry Eade were sunk by having a bomb placed on board. Both crews were transferred briefly to the U-boat before making their way to Whitby by their own ship's boat where they were looked after by The Shipwrecked Mariner's Society. One of the sailors reported how well they had been treated by the German crew although they took most of their food and money as well as seagoing kit including oilskins which the U-boat commander made them give back.

The *Quebec (SH 208)* skippered by John William Foster of Whitehead Hill, Sandside, had a narrow escape this time as Skipper Foster recounted at the time;

'We were heaving our gear up on Thursday morning as near as I can say about six o' clock, about six or seven miles east-south-east of Skinningrove, when one of the men shouted out 'Dalhousie's gone!' (she was about 400 or 500 yards away from us on the eastern side a few minutes before. We saw the Dalhousie sink and about five minutes after the smoke had cleared away, we saw the submarine about 400 or 500 yards away from us on the eastward. A small boat was being rowed towards land with the Dalhousie's crew and we on our part kept close to the land and made for home at full speed. We saw the submarine head for land also but whether she intended coming for us I cannot say - we did not give her a chance. We took the precaution to clear our small boat out, expecting it would be our turn next. We continued to head for land until we could see no further trace of the submarine. Afterwards we went after the Dalhousie's boat. We came up with her about seven o'clock about three miles from Whitby. We spoke to the men for a matter of a few minutes and upon them telling us they were going to put in at Whitby, we headed for home, arrived in Scarborough about eleven o'clock on Thursday morning.'

Then, in September 1916, the Scarborough fishing fleet was all but wiped out by the activities of the commander of one of the German Navy's underwater craft, the U-57, commanded by Kapitanleutnant Carl-Siegfried Ritter von Georg. von Georg had already been present at the shelling of Scarborough in December 1914, but by 1916 he had been promoted and given command of a 'U' Boat.

Covered by the darkness of night on the 24th/25th September 1916, U-57 surfaced in the cold waters of the North Sea and found 14 trawlers, easily identified by the top lights they carried for navigation, and sailing without the protection of naval protection vessels. There one by one von Georg ordered the crews, totalling 126 men, off into the 14th, the *Fisher Prince*. U-

57 then sunk the other trawlers with gunfire, waving a farewell *'Auf Wei-dersein'* to the men he had not consigned to a watery grave. The fishermen were transferred to a neutral Norwegian ship passing by who landed them at Hartlepool. It is interesting to compare the different views of the action on the German and the British side;

'Two Views of the Sinking of the Fishing Fleet'

The German View

Translated from the naval records of the German U-Boat Archive at Cuxhaven;

'The following operation by U-57, captained by Lieutenant-Captain Georg, is of particular note:

At the end of September, the boat was in a holding pattern off Scarborough on English east coast. As no warships had been sighted for three days, the commander decided to wreak havoc amongst the numerous English fishing boats in order to use the time advantageously. On 24th September he (Georg) stopped and sank the English ships Devonshire (Type 148), Briton (Type 134), Aphelion (Type 197), and Albatross (Type 158) as well as the Norwegian ship Laila (Type 735) which was carrying pit-wood from Archangel to England.

During the night of 25th September, U-57 succeeded in sinking the English fishing boats St Hilda, Trinidad, Marguerite, Loch Ness, Nil Desperandum, Otterhound, Sunshine, Otter and Ta-rantula, Types 74 – 176, in the course of one 10-hour operation. All the crews from the enemy fishing steamers in the area were

put on board Fisher Prince, the first steamer captured when U-57 went alongside, under the command of Sea Lieutenant Ruckteschell. After this had been carried out without incident, the watch officer sailed with his privateer behind him and under cover of the night went in front of the nets of other steamers and sank them noiselessly and stealthily by opening their bottom valves. In this cunning manner every single fishing steamer was surprised and unable to flee.

Furthermore, enemy observers which were all over the English coastal waters, were not called to the scene by gun or shell fire. After daybreak on the 25th September, the English fishing boats, Gamecock, Harrier, Quebec, Seal and Cynthia, Types 133-162, were sunk by gunfire after their crews were taken off. Finally, a Norwegian steamer, whose papers were in order, was forced to take on board the fishing crews which had been gathered together on the Fisher Prince which was the last ship to share the fate of the others. Thus, in the shortest possible time the considerable catch of 19 fishing steamers was removed from the enemy market.'

The British View

from The Scarborough Evening News;

'When a U-boat Sank the Scarborough fleet'

'When darkness fell on 24th September 1916, 12 Scarborough trawlers were fishing on Whitby Fine Ground, 20 miles north east of Scarborough. All of them, except Ben Hope (SH 240) were in close proximity to each another.

Lights (oil lamps) on their masts indicated to other vessels that the trawlers had their nets down.

There were no blackout restrictions at sea until the convoy system started in 1917.

The trawlers fishing together were Fisher Prince (SH 207), Gamecock (SH 191), Harrier (SH 30) Marguerite (SH 214) Nil Desperandum (SH 186) Otter (SH 70) Otter Hound (H 92) Quebec (SH 208) Seal (SH 126) Sunshine (SH 241) and Tarantula (SH 184).

Suddenly, a German submarine (an untersee boot or "U Boat" surfaced alongside the Fisher Prince and German sailors swiftly swung grappling hooks over the trawlers side. Armed raiders, led by the 'U'-boat commander boarded the Fisher Prince.

Speaking in English, the commander told the trawler's skipper (Dave Naylor) to "Stop the engines and hand over the Ship's Register". Then Skipper Naylor and his eight crewmen were marshalled into the trawler's fish hold.

Leaving a "prize crew" aboard the Fisher Prince, the German commander and his escort retuned to the U-boat. Without submerging, it sped silently across the sea and pulled up alongside the Otter Hound.

A raiding party boarded the trawler, where the skipper, Jim Blackman was ordered to "Stop the engines and hand over the Ship's Register". Five minutes later, Skipper Blackman and his eight crew were hustled aboard the U-boat.

Three German sailors confiscated all food supplies- except the beef- which were aboard the Otter Hound. The captives were ferried to the Fisher Prince and imprisoned in her fish hold while the U-boat captured 12 trawlers fishing nearby.

They were nine Scarborough trawlers plus two trawlers with Scarborough crews – Saint Hilda of Whitby, skippered by Billy

Hall, of 5, Potter Lane, and Loch Ness, of Hartlepool, skippered by Dick Wright, and a Hull trawler named Trinidad.

Each of the trawlers was stripped of all food supplies. Its ship's register was taken by the U-boat commander, as proof he had captured and sunk them.

All skippers and crews of the 13 trawlers were taken by the U-boat to the Fisher prince and put in its fish hold, which eventually contained 126 men (nine per trawler). They were guarded by four armed, but not unfriendly, German sailors.

In a methodical manner, the U-boat's crew destroyed the 13 captured trawlers. Twelve of them were sunk by gunfire, where shells made holes in the trawlers' hulls so the vessels filled with water. The Nil Desprandum (the 10th vessel to be destroyed) was sunk by a time-operated bomb.

According to British Admiralty records, seven trawlers were captured on the evening of 24th September; six of them were sunk before midnight, the Fisher Prince being retained as a prison. Seven trawlers were captured and sunk during the early hours of 25th September.

One Scarborough trawler evaded capture because she was fishing away from the main fleet. She was Ben Hope (SH 240), owned by Dick Crawford and skippered by Walter "Wanny" Crawford, of 34, Cook's Row.

Hearing the noise of gunfire early on 25th September, Skipper Crawford ordered his crew to haul in the trawl net. Then with her catch aboard, the Ben Hope steamed home at full speed.

Just after dawn on 25th September, the U-boat stopped a northward bound Norwegian cargo ship. On boarding the neutral ship, the German commander arranged for her captain to convey 126 fishermen to a British port.

Dave Naylor and his crew were ordered to start up the engines of the Fisher Prince and manoeuvre her alongside the cargo vessel. Bidding the captives "Auf Wiedersehen", the German commander told them to board the Norwegian ship.

Before submerging, the U-boat sank the Fisher prince with gunfire.

All 126 fishermen were landed at South Shields, where they were cared for at the Mission's to Seamen's Institute. The next day they returned home by train.

Each of them knew the German commander could have sunk the trawlers with their crews aboard in a few hours. Only a humane man would have kept his U-boat in enemy waters for 10 hours to "save" 126 British fishermen!'

In addition to the losses sustained by U-boat and mine, several other fishing boats were commandeered by the Admiralty for mine-sweeping duties, whilst one was commandeered as a transport in the Dardanelles campaign against the Turks at Gallipoli. Three of these were the *Morning Star* (*SH 61*), *Vitality* (*SH 63*) which was sunk on the 20th October 1917, and *Rosy Morn* (*SH 59*).

The fishing fleet never recovered during the war, being reduced to just three trawlers; James Johnson's *Penguin* (*SH 223*) together with Dick Crawford's three remaining fishing craft, the trawlers *Ben Hope* (*SH 24*) and *Scorpion* (*SH 182*) and the drifter *Gamester* (*SH 204*). or to its former glory afterwards, the remaining boats of the fleet having been moved north to other ports including Aberdeen. Most of the 126 trawlermen whose boats had been sunk moved north to Hartlepool or even further north to work with the Aberdeen fleet from where many never returned. In early 1917 Scarborough was completely closed as a fishing port by the Admiralty and

the remaining boats joined the Aberdeen boats to fish only in convoy from then on.

Then, as a final act of war on the non-combatant people of Scarborough, on Tuesday 4th September 1917, at about 6.45 p.m. another U- boat surfaced off the Scarborough shoreline and fired 30 shells at the town, killing 3 people and injuring several more. The U-boat was never identified and may well have been lost at sea, very possibly by hitting a mine.

Gallery: Images of U-57 and its Crew

The author wishes to thank the curator at the Cuxhaven U- Boat Archive for supplying the following rare images to Len Friskney for use in this work.

Fig 52: The crew enjoying a beer between missions.

Fig 53: The crew shown in the accommodation area of U-57

Fig 54: A contemporary photograph of U-57 on the surface with its radio masts extended

*Figs 55 & 56: Kapitanleutnant Carl-Siegfried Ritter von Georg (1886 – 1957)
and the crew of U-57.*

SUNKEN SCARBOROUGH TRAWLERS.

1916
JULY 21st

INTERVIEWS WITH FISHERMEN

SKIPPER'S STORY.

The following interview with members of the crews of the Scarborough trawlers concerned in the attack by a German submarine are passed for publication by the Press Bureau:—

CREWS WELCOMED.

On the arrival of the crews from Whitby—the skipper of the Dalhousie had remained until a later train—at 5.45, they were heartily welcomed at the railway station, many hearty handshakes taking place, and congratulations intermixed with regret that the German sailors should stoop so low as to sink innocent fishing vessels. The men, however, all spoke highly of the courtesy of the commander of the submarine, and one interesting item was forthcoming in the following fact: When the German sailors were put on board the Dalhousie they discovered two new oilskins, which they took, but on returning to the submarine the commander ordered them to return them to the men.

COURTEOUS GERMAN COMMANDER.
FOOD, CLOTHES, AND MONEY TAKEN.

About other things, however, they were not so particular. The skipper of the Florence said that his vessel was blown up at about 8 o'clock. The Florence would be about eight or ten miles from the Dalhousie. The crew had to go on to the submarine, where they remained for about twenty minutes, and he said that they were well treated. They took most of the eatables, however, from the trawler, and even took kits and clothing and money. The vessel was blown up by a bomb which was placed on board. The crew took to their small boat, and the weather being fine and the sea smooth they got to land safely. At Whitby they were well taken care of by the Shipwrecked Mariners' Society.

Another member of the crew said the Germans took off all food except beef. They actually took money belonging to the crew. The Scarborough trawler Quebec seems to have had an extremely narrow, if not providential, escape, as can be imagined from the following story communicated to our reporter by the skipper, Mr. John William Foster, at his home, Whitehead-hill, Sandside.

He said: "We were heaving our gear up on Thursday morning as near as I can say about six o'clock, about six or seven miles east-south-east of Skinningrove, when one of the men shouted out, 'Dalhousie's gone!' (she was about 400 or 500 yards from us on the eastern side a few minutes before),

We saw the Dalhousie sink, and about five minutes after the smoke had cleared away we saw the submarine about 400 or 500 yards away from us to the eastward. A small boat was being rowed towards land with the Dalhousie's crew, and we on our part kept close to the land, and made for home at full steam. We saw the submarine head for land also, but whether she intended coming for us or not I cannot say—we did not give her a chance. We took the precaution to clear our small boat out, expecting it would be our turn next. We continued to head for land until we could see no further trace of the submarine. Afterwards we went after the Dalhousie's boat. We came up with her about seven o'clock about three miles from Whitby. We spoke to the men for a matter of a few minutes, and upon them telling us they were going to put in at Whitby, we headed for home, arrived in Scarborough about eleven o'clock on Thursday morning."

Asked if he saw anything of the Florence, Skipper Foster replied in the negative.

The Dalhousie left Scarborough for the fishing grounds about 2-45 on Wednesday afternoon.

A CHAT WITH SKIPPER OF THE DALHOUSIE.

Harry Eade, skipper of the Dalhousie, in a chat with our representative, said that it was about 5-30 when the submarine hailed them. They were told to get into their boat, and go to the submarine. An officer from the submarine with five or six sailors then got into the boat and went to the trawler which was blown up by means of a bomb.

Did they take food, your clothes, and money? he was asked, and he replied: They took some clothes, and food, I don't know about money.

He added they were on the submarine about twenty minutes and then they got into the boat and made for land. When they had first got in the plug was out, but they stopped the hole up, and got the water out. It was very difficult at first.

He was met at the railway station by relatives, and given a warm welcome, so much so that he exclaimed in typical sailor-like fashion: Why, I might have been away for eighteen years!

Fig 57 & 58: Contemporary press cutting from the Scarborough Evening News 21st July 1916 (Courtesy Len Friskney collection)

Note the permission of Press Bureau (the censor) had to be obtained before publication. Both sides in the conflict were avid readers of each other's press both to seek intelligence and to gauge public opinion on the war.

Chapter 5:

'One Day in December'

This chapter is included in the book to give prospective producers of the community play *'One Day in December'* a brief outline of the production itself together with its background story. In the programme for the first production the play was described in the following words:

> *'Using light, sound and music blended together with the spoken word, the community theatre production, 'One Day in December' is based on the war poems of Wilfred Owen and the momentous day in December 1914 when Scarborough was bombarded from the sea.'*

It was to be a moving and highly memorable journey of community interaction which started in late 2013 when the 'Third and First Age Theatre Company' (TAFAT) approached Westborough Methodist Church at the suggestion of Denise Gilfolye, then outreach manager at the Stephen Joseph Theatre in Scarborough. From that meeting it was suggested that an approach to the church's youth community to explore their involvement in the production of a piece of community theatre might be of interest.

Mark Haynes, the then Minister of the church, and Elsa Monteith in the office, both encouraged the idea and the Westborough Church community seized the opportunity with open arms. Directed by Lucy Lowe with musical direction by Mark Gay from a short story by the author of this book, the production incorporated an artistic display entitled *'The Futility of War'* by local artists Angela and David Chalmers. (See Chapter 7). The production was

launched in association with the Scarborough Museums Trust, the Scarborough Maritime Heritage Centre and members of the Westborough Community.

'One Day in December' is a community play designed to help address issues of intergenerational conflict. It does this by bringing together members of the same community (or separate communities if required) who explore the story of conflict and its resolution that form the central theme of the play. The story is based around the World War One 'Bombardment of Scarborough' and the war poetry of Wilfred Owen written during his time in the town.

The play is based on a one act scenario involving four characters; Freddie, Roxanne, Gran and Wilfred Owen. This is followed by the community theatre aspects of the production where the storyline suggests the conflict within the plot is to be resolved through the medium of a stage performance, which itself involves a number of short sketches of around five to ten minutes each. In this production the community divided into five groups representing the various uniform youth groups who were to be involved, but the number of sketches can be dictated by the size of the community who are exploring the production.

The sketches were almost entirely the work of the community members involved but with some central encouragement and 'steering' to ensure the overall integrity of the production was maintained. This meant the younger and older people involved were required to talk with each other, discuss the issues, research their sketches, rehearse together and finally perform together, possibly for the first time in front of a public audience. The process was exciting and moving for those involved and in the first production the ages of those involved ranged from 5 to 87 with a lot of people saying how much the production had benefited the community and each individual within it.

One of those who took part was Louise Stanway, ('Connie' in 'The Lost Scout') the mother of three of the performers; Evie, Huw and Will. She had this to say about the production;

'To me, one of the most amazing things was that, after a lifetime of involvement with the church, I was present when the communities that make up the congregation all came together for this play. I knew most of the people involved and to see them performing together like this in what was their own creations was incredible. My own children were all involved; to see them performing was very special. My middle child was quite shy and to see him standing there in front of a live audience singing a solo was an amazing experience. Just to see him come out of himself like that was a thrill.

The whole church community came together with other parts of Scarborough; a sort of double benefit that created something really unique. You couldn't replicate that night again; it would be different every time you ran the play and it would be impossible to capture the levels of emotion in a repeat performance each night; each production would stand alone.

Looking through the cast list at all the names, there was one lad I know who would never, ever, have been involved in something like that; he would never have had that opportunity. I know he remembers what he got out of it because he tells me; he got as much out of it as any of us and he went onto great things. Now he represents the UK in athletics in his age bracket.
I loved the way the play built confidence in very unconfident kids; it was long term confidence building to me because the kids saw the value of being with the older members of the community; all being involved together; they saw what each other was getting out of it and what they had to give; it was all about what

each age group could learn off the other; it was truly outstanding.

The poem of Wilfred Owen at the end of the production (Dulce et Decorum Est); that stuck in my mind for ever – coming up through all the smoke, the mist, the green lighting, the noise of battle; I can picture the actor now, Bill, coming through it all in First World War uniform reading the poem; just so emotive. It's still as clear as day, five years on. And the fighter pilots running around the church; how could anyone who was there forget that! Two young boys having the time of their life dressed in flying helmets and goggles and with cardboard wings strapped to their arms – it was brilliant; so great to see; and great theatre.

Our kids have gone on; both the boys have won drama awards at Saltburn Drama Festival and at Sedgefield. And music; 'One Day in December' was one of the boys first live performances and five years later he's a gigging musician. It's a great concept; everyone in the community working together to the same end; true cooperation to make it all work. It was wonderful.'

Fig 58a The Stanway family who appeared in the sketch 'The Lost Scout'.

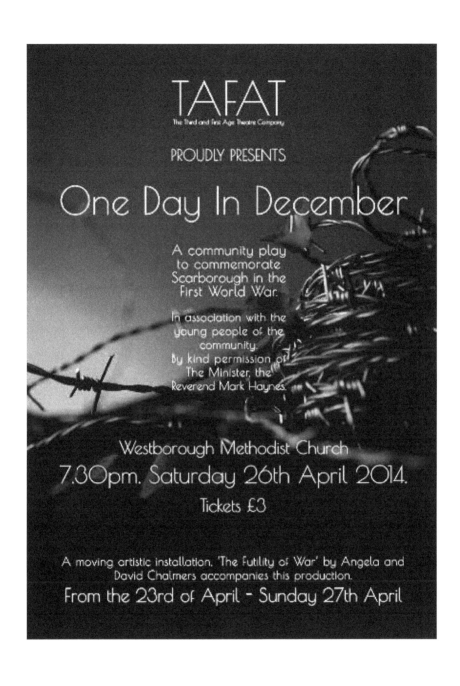

Fig 59: The advertisement poster for the first production of 'One Day in December'

'One Day in December': The Short Story

by D.B. Lewis

There's an ageing white hotel on Queens's Parade - the 'Cliff Top' which is quiet all through the winter week. Busier at weekends of course; hectic at Christmas. A place where the name matches the blurb in the brochure if nothing else does; a place where only the summers are really busy enough. And it was only then that Freddie Wright reluctantly helped out, usually in the basement kitchen or clearing dishes for 'cash in hand.' It was the way he dodged his mum and 'good old Gran' who'd never really understood him. Especially not since Dad had left – they were far too busy with guests to have much time for a difficult hotel 'run-rat' even if he was an only child.

Freddie's main escape was 'in his head' as he called it. He was a gamer. Gran sometimes had a pop at him for 'playing stupid games when he should be doing coursework' but he didn't care. Freddie remained sublimely locked in vivid worlds of inter-galactic lights and extra-terrestrial sound, kaleidoscopes of coloured images way beyond the mortal world: it was thrilling, fun, a truly three-dimensional journey through the mind, a virtual paradise in 'CGI' where he could taste the surge of power, smell the glory, feel the energy of orders given from his own nail-bitten fingertips. When he was in what he called 'the zone', he went to where his mum and Gran could never go; they were stuck in their little sepia world, like the fading photos on the hotel wall with the grime of endless hotel guests and all their grasping needs. Freddie hated guests.

For their part his mum was overworked, his gran old before her time; always coughing up from all the fags she'd gasped second-hand in the hotel bar before the ban. Of *course,* this was a family place; a fourth generation of lodging-house keepers whose fortunes had waxed and waned according to the tide of the small town's fickle affairs. It wouldn't go to a fifth, Freddie intended making sure of that.

At school, this year's battleground was 'history;' the anniversary of the Great War and that bloody Owen the two of them kept harping on about. 'Roll up, roll up, come up and see 'Wise Old Wilf's Wild War Show' he would shout to passers-by who stopped to stare up at his third-floor turret of a room perching nervously within the whitewashed hotel walls. It wasn't just the dismal salt-caked disc in almost-blue either that clung despairingly to the fading flaky paint of this once proud place. War didn't fool Freddie one little bit-he knew that Owen, like most of the poppy pedlars, had died well before his time. What was war to Freddie Wright he'd say to himself? He wouldn't have to fight, would he? *He* had more sense. War was in the past-the distant, long forgotten past, thank God and best left there for all he cared. A total waste.

Freddie's closest 'friend,' of not so very many, was Roxanne Smith; 'Roxy' as he called her, although she didn't really like the name. They were in the same class. Roxanne was diligent at school, a 'swotty little snot' as Freddie once called her years ago, or a four-letter word far worse when Mum and Gran weren't there. She was in the local scouts, bubbly and bright, lively with a sense of adventure; quite the opposite to 'Foggy' Freddie as some of the class called him; thick, wet and always there when you didn't need him. Unlike Freddie, unkempt and unwashed in his stained shiny shell suit, Roxy was attractive and wore her fading jeans black and low like she'd seen on the boys in town with red retro 'bumper' shoes and baggy tops. But womanhood wasn't far away; she wore her *'Peter Andre'* perfume boldly over a shapely body, small and delicately thrown, just like a Wedgewood dish. Not that Freddie noticed. So long as he could bury himself in games he was as happy as a box of fudge on an empty beach. On the day she planned to call and see Freddie, Roxanne realised it would be more in frustration than from any sense of fun. But she would persevere; he might grow up. One day.

It was the morning of the thirteenth of December, a Saturday that had dawned dismal and damp; a dark, 'cold as a crab' sort of day with a persistent, nuzzling drizzle like the nose of a dog on the back of your leg; a dog that wanted *something urgently* and wouldn't give up. When she called,

Roxanne would find the hotel half-full with half-board Christmas shoppers, the drunken party stopover with a *smorgasbord* of a hangover and a couple who'd been to the panto and couldn't get home. And she would find Freddie hunkered down in his attic room with his switched-on 'X' box, last month's clothes, and his latest acquisition- 'Crack Castle Raiders;' drug dazed dope heads from someplace like Durham where his dad was, Freddie thought, holed up in a castle with the 'Dark Knights' as alien invaders laser-lashed the crumbling walls. It was a game where the player had to decide on the lesser of two evils - Freddie loved those. A kind of moral tale of our times where the power of evil could be released or suppressed according to the skill supplied by the gamer. Mum wouldn't like this one then, Freddie reckoned, his gran even less, but sometimes, life was all about choosing the best dead dab from a net full of dead dabs wasn't it? He would be the hero in his own story; it was he, Freddie Wright, who'd find the resolution-*they* wouldn't understand it, not at all. And then, back in real time, he remembered the eponymous Roxy was due round at twelve o'clock...'after he'd finished his homework' Gran had said.

At half past eleven it was Gran herself who'd come up the stairs, right up to the floor below the attic overlooking the bay – a long climb for an old lady.

'You done your homework Freddie?' A predictable call drifting through the tightly closed door.

Freddie kept quiet.

'You should be good at this week's work seeing as your teacher says you're doing Wilfred Owen-'e wrote some of 'is stuff in this very hotel. Before 'e went to war that was...

'...eeee, in 1917...' Freddie sarcastically shouted back, mimicking his gran's weary voice that could never find the 'h.'

'...'e 'ad the room at the front...'

Freddie kept his thoughts to himself. Of course the old git did. Don't be stupid Gran ...it's called the 'Owen Room'...on account of that was where he stayed... there's a sign on the door saying so. 'Wilfred Owen stayed here 1917-1918.' I pass it every day. You *know* that. She was like a blip on a dusty CD, his gran: stuck in a grey plastic groove with the lights turned low. She didn't like the steps to the attic though-too steep for her... or was it something more? Too much trouble? Maybe he wouldn't have to see her anyway, that was something.

'It's haunted that room Freddie...when you're done, come on down and I'll show you something I bet you've never seen before.' The voice sounded more urgent this time - as if a sense of sinister foreboding had descended on the place like that Angel of Mons he'd seen on the cover of his unopened history book.

'OK Gran,' he shouted 'maybe Wacky Wilfy's ghost can tell me why we keep on going to war then? That would be something useful at least. Wouldn't it? And don't fret so much-I'll be down in a minute.'

Freddie heard Gran leave the landing, open the squeaking door to the neat white simplicity of the 'Owen Room' and then nothing more. It was the best room in the building by far. It must be, it said so on 'Trip Advisor.' It also said the room was reputedly haunted but his mum kept it locked from the prying eyes of gullible guests who might want an unpaid look. But he thought he'd better humour Gran or she might send Roxy away. Today he needed 'Little Miss Compliant' to help him move to the next level of the programme; the *ultima thule* of the gaming world. To defeat the awesome power of the alien invaders he would have to pitch himself against another player this time, not just the programme. He would play with Roxy. He would win. Evil might triumph over good again and the 'Dark Knights' might just see the light of day.

Freddie passed along the narrow red walled landing which smelt strangely of lavender and cabbage until he came to 'Owen's Room.' Gran was standing there, just inside the white-limed door, looking out over North Bay; crying maybe? He saw her... covered in a swirling dust-white mist; the

room seemed full of smoke dancing in eddying streams that caressed her long white chintzy dress, coiling up to meet her short wispy hair, white on white on white. All around a low dark voice boomed out - a voice he felt tugging away at some deeply sunken shaft of memory hidden far, far down in his lonely soul; instinctively he knew the voice; the voice that could only be that of his nemesis, their very own ogre Wilfred Owen. The ghost had come again... to spirit Gran away? He stopped as if struck rigid like pillars of biblical salt but still the voice droned on. He recognised the poem as the one his teacher knew by heart, the one they'd been set to study; 'Dulce et Decorum Est.' Then, without warning, he heard the bang of a distant door closing sharply, and Freddie realised with a start that, once again his day had drifted into yet another dream. But this time his thoughts wouldn't go away. He saw his teacher standing there, talking to him. 'It is sweet and right to die for your country,' Wilfred Owen had written in Latin. 'Bollocks Miss,' Freddie Wright had said in English. 'Owen was right on that one, wasn't he?' But Freddie remembered she'd excluded him for using such *awful* language just the same.

It was Roxanne who'd slammed the door that broke the spell. She'd walked into the open hotel lounge and, as she cried out to find out where they were, the swirling, streaming smoke had simply disappeared. Now, Gran was pushing Freddie up the stairs.

'Stop all your dreaming and do your coursework, Freddie, I want a quick chat with Roxanne – we'll only be a minute and when you're finished you can play your silly little games ...it won't take long whilst...'

The sentence hung in the silent air. The 'whilst it's fresh in your mind' part left unsaid, unneeded. Freddie knew exactly what she meant. They both knew. Perhaps it wasn't just a dream?

Downstairs in the empty kitchen, Gran sat Roxanne down at the stripped-pine table with the marbled top where the business end of the

hotel took place. It had a smell of spilt wine and crushed garlic evocative of all those family holidays in France. She felt at home here.

'Roxanne, dear, I need your help,' Gran said. 'Freddie's falling behind in class; the teachers say 'e isn't doing any homework and 'e got himself excluded last week...me and 'is mum are worried...any ideas?'

'I've been thinking about it too Mrs Wright, he just doesn't get it... not at all and now he's started messing up the class; acting strange, swearing and coming out with some pretty wacky stuff. The teachers' right fed up with it I know...I'm right fed up with it actually...I was wondering if... well... maybe there was any family link to the past-to the First World War perhaps that might help his over-active imagination? It's such an important part of the course - all the causes of conflict...that's why we do so much on it...but Freddie won't listen-says it all a load of...'

Gran quickly cut her off... 'Well, there's a few medals from the Boer War in the box room upstairs and a photo or two...nothing else much but...wait a minute...'

'What is it Mrs Wright...?'

'Have you ever seen Freddie with that old metal engine on the stand...?'

'...the one with the wheel on the side, a bit like an old Meccano toy like you can see down in the museum?'

'Yes, that's the one, ' Gran replied, 'Freddie keeps it in the drawer by the side of 'is bed-I'm not sure why but 'e's very attached to it for some reason-always polishing it and messing around with the wheel and that... it's as if it somehow reminds 'im of 'is dad-not that 'e cared much...'

'Where did it come from' said Roxanne.

'It was passed down from 'is great great grandfather - the one who was a soldier and fought in the Boer War; the one in the photo with all the medals, a right charmer he were by all accounts.'

Roxanne was intrigued by anything to do with the past - especially the past of the boy she was hoping she might have some very modern thoughts about quite soon, so she pumped his gran as far as she felt she could;

'What happened to him?'

'...wounded at a place called Magersfontain in the Cape Colony during the Boer War or so 'is letters say - so bad it were that they sent 'im home- after the camp that was. 'e became a postman like his brother back in Scarborough - bit ironic really as Arthur, who'd never seen a gun nor raised a word in anger, 'e was killed, peacefully delivering letters in Filey Road during the bombardment. And there was our 'enry,' a soldier through and through, survived, h'ornted to 'is very dying day with what some call them 'vicious scars of war.'

'The bombardment? Was that when the German ships shelled the town in 1914, I've read about it, 'replied Roxanne.

'Yes, back then was when they first realised that war had come to us, the people, in our 'omes-that now we would be in the front line just like them Tommie's in the trenches. Though not so wet.' In fact, the anniversary is this week – on Tuesday...'

'Well, maybe we could find a link – I could ask the scout leaders tomorrow - see if they will help? We could find out all about Freddie's great granddad and drag him along, Freddie I mean, it's parade night on Tuesday with everyone there - he could hardly refuse if it's all about him surely?'

Gran, a confirmed believer, had laughed at the thought of Freddie's great great granddad paying them a visit but Roxanne was good to her word. On the very day of the one hundredth anniversary of the 'Bombardment of Scarborough' as it was called, the scout leaders had agreed to Roxanne's plan – they would make a night of it commemorating the momentous events and they'd call it 'One Day in December.'

Parents were invited and the hall filled rapidly as Freddie nervously stuck his head round the door. He had come because Roxanne had

riled him saying he wasn't half as brave as any of his family; even his dad had been braver - it was that which hit him most but he would show Roxanne; show his mum and Gran - his father had been a bloody coward in his eyes and he would show them, one day he was going to be someone. Like his great great granddad.

Roxanne spotted the change-fierce, belligerent, angry-a boy who suddenly had 'attitude.' He seemed to have grown taller, wider; older even. 'Maybe this wasn't such a good idea after all,' passed across her mind.

'It's ok, Freddie,' she said to try and calm him down, 'You're not on 'til later - after everyone else has done their skit-each group has five minutes and then it's you.'

By nine o'clock the five uniformed groups; the scouts, the guides, the boys and girls brigades, the St John Ambulance, all weekly users of the hall, had finished their pieces to loud applause - parents were universally discerning in these things - and then it was Freddie's turn. His mum and Gran had turned up just as Freddie took the stage, the engine neatly tucked under his arm. He placed it carefully on the table provided and spoke in a loud, slightly shaking, monotone;

'My dad gave me this, it's a model of a Static Turner Engine, its over 100 years old and it was made by my great, great, granddad. See all this bare metal... the shiny bits-they're made of old shell cases that he was given by the Boers when he was in a camp hospital...this one's the main piston...it was made from the bullet the doctor took out of his leg...the doctor told him to look after it so he'd remember and he put it into this engine.'

Angry tears of frustration and embarrassment spat down Freddie's cheeks as he mumbled the last few words but just loud enough to be heard in the silent hall.

Freddie picked up his engine and sat down, the silence pressed on his skin like soda straining to break free from a pump. Then, as one, the hall stood. Stood and clapped in continuous applause. Applause for Freddie, for

the scouts and the guides and the brigades...long, long applause as the performers came to the stage and took their bow, the strands of 'Scarborough Fair' swamped out in the background. The night had been a huge success. Roxanne leant over and placed her very first seductive kiss on Freddie's gaping lips whilst his gran hugged him firmly from behind. Freddie's heart beat faster and he smiled.

Freddie wouldn't be a silent hero; back at school he would be asked to lead the next assembly; talk about his great great grandfather, about the bombardment; of Owen and his ghost. He knew now what he wanted to do with his life; he would work for peace. He would re-join the world and find a way to deal with the violence of those around him. Now, he knew what the engine meant; the engine that had so far stayed silent. One day, Freddie promised himself, he would make it work again, he'd discover the missing parts and make the static wheel spin once more.

He listened intently as the evening finally closed with the old grey scout leader facing the memorial window in that hall full of stained-glass images and heard him announce the poem he knew so well. The familiar booming voice drowned the silence.

''Dulce et Decorum Est' by Wilfred Owen' it said.

Freddie remembered the overwhelming feeling of that moment in 'Owen's Room' when his whole body shook and he knew, knew absolutely, he'd never, ever be the same again.

Fig 59a: The theatre space at Westborough Methodist Church, Scarborough.

'One Day in December'

A One Act Community Play

by

D.B. Lewis

Based on a short story

Dramatis Personae

Freddie
A rebellious, gaming schoolboy; the only son of the owners of the 'Cliff Top' Hotel, Scarborough.

Roxanne
Freddie's intelligent and hard-working 'girlfriend.'

Gran
Freddie's long-suffering grandma who helps his mother run the 'Cliff Top.'

Wilfred Owen
A rather unlucky War Poet, killed one week before the Armistice.

Young people, older people townsfolk and parents
Members of the local community who attend a review at the local Church Hall.

In the first performance of the play the parts were played by:

Freddie	Mark Palmer
Roxanne	Jen Davis
Gran	Barbara Halsey
Wilfred Owen	Bill Hammond
English Fighter Pilot	Rory Ruston
German Fighter Pilot	Damien Quinton

Sketch One: 'The Universal Soldier'

Sketch Two: 'Anthem for Doomed Youth'

Sketch Three: 'Old Time Music Hall'

Sketch Four: 'Remember Scarborough'

Sketch Five: 'The Lost Scout'

The action takes place inside the Cliff Top Hotel, Queen's Parade (a street in the seaside town of Scarborough), and in the local Church Hall nearby. It is the 13th - 16th December 2014.

Scene 1:

A Church Hall; members of the local community enter and take their seats. Young people, members of various uniformed youth groups, move about

the seats offering programmes to the audience. Music plays. A 'Scarborough Fair/Wonderful World' medley.

When the audience is seated, the lights dim. The sound of marching bands is heard in the distance. Five marching columns enter with flags to the sound of the band. Lights up. The flags are handed to a 'Master of Ceremonies' and the columns retire singing a 'Tommy's' marching song of the First World War.

Song: 'It's a long way to Tipperary...'

(The flags remain)

Scene 2:

(Freddie's attic bedroom at the 'Cliff Top' Hotel. There are clothes strewn untidily around and a PC and music speakers on a table in the centre of the room.

Enter Freddie, dressed in a hoody, running, carrying a CD in a case and shedding clothing as he goes.)

Freddie ...what an awful racket!... Right outside my room; snotty Scout's Saturday parade practice-why they can't they keep the doors shut like they're supposed to? It's not 12 o'clock yet and by rights I should still be in bed. Anyway, early start won't kill me- my new game's just come...This'll sort them, no worries....

(He places CD into the PC and switches on the game and his i pad. The room goes wild with lights and music, arranged version of Sam Cooke's 'Wonderful World' mixed with a beat version of 'Scarborough Fair' to which Freddie sings 'Don't know nothing 'bout history... along to the music: played loud. The game 'Crack Castle Raiders' appears on a screen and shows alien space craft at sea laser-lashing a castle containing the 'Dark Knights.'

At the same time, First World War model planes appear from their hanger, searchlights seek them out as they 'drop bombs' and dogfight... smoke eddies about. The planes crash land back into their hanger to a burst of smoke.

Freddie is whooping and ecstatic and as the 'game over' sign appears on the screen, the smoke disappears. Freddie throws himself to the floor in a fit of exaltation catching his head on the table as he does so. There is a loud banging on his bedroom door.)

Roxanne *(off)* Freddie! Freddie! Open this door, what on earth's going on in there? Open the door Freddie. It's me, Roxanne. Please Freddie let me in...turn the music down, it's supposed to be a hotel for heaven's sake...

(Freddie staggers about, dabbing his head. He opens the door.)

Enter Roxanne

Roxanne About time, I've been knocking for ages. How loud is that?
(Switches music off.)

Freddie What's the matter with you then, Roxy...got swotyitis again I suppose ,'Look Miss I've done all my coursework,' 'go to the top of the class.' This is much more useful than all that war crap, just have a look at this – it's awesome, unbelievable...you wait till you're playing- it'll blow your head off...

Roxanne Not today Freddie! It's the last Saturday of term remember? Coursework has to be in by the end of next week... we agreed we'd finish 'Causes of Conflict in World War One' together didn't we? Or in your case start it...

| Freddie | Oh no, I forgot. I hate all that war stuff… history's just so boring… it's all in the past… |

(…he sings 'Don't know nothing 'bout history, don't know nothing 'bout geography' two lines only)

| Roxanne | Everything's boring to you these days isn't it? History, Geography, you're turning into a right geek…the only thing you have any time for is your stupid 'X' box and all these crappy games you keep buying. It's not sur prising you were excluded last week - I'm surprised the teacher has put up with you this long. If I was your dad I'd have left ages ago… |

| Freddie | You leave my dad out of this understand? He went be cause he's a lousy no good drunken two-timing git, that's what Mum said. I never want to see him again…ever… and they're not crappy, they're educational; this one's all about a castle and alien invaders from the sea who try and terrorise the town…sound familiar? You know you're starting to sound like my gran. |

| Roxanne | Which reminds me, she says I can't have anything to do with you or your new game, until you've finished your coursework, as if I would, so pull your finger out and get it sorted. I'll do mine on my own if this is your attitude. Anyway, your gran says I can use the kitchen now the chef has gone. By the way she's on her way up to see how it's going. Bye Freddie… |

(Exit Roxanne)

| Freddie | Shoot...she'll kill me if she finds all this mess. She doesn't usually get up as far as this but I bet she has a really good try today just to be *really* annoying... |

(He picks up clothes placing them in a new heap)

| *(Shouts)* | I so hate living in a hotel! Especially this one. If I hear any more about that Wilfred Ruddy Owen I swear I'll go to war myself. And Mum and Gran will be the evil enemy. |

(He blasts them with an imaginary machine gun. There is a sound of a person climbing stairs slowly, a door creaks.)

| Gran *(off)* | You done your homework Freddie? |

(Freddie tenses and stands rigid as if in pain.)

| Gran *(off)* | You should be good at this week's work seeing as your teacher says you're doing Wilfred Owen - 'e wrote some of 'is stuff in this very hotel. Before 'e went to war that was... |

| Freddie *(mimics)* | '...eeee, in 1917...e 'ad the room at the front...' |

| *(then to himself)* | ...course the old git did. Don't be stupid Gran ...it's called the 'Owen Room'...on account of that was where he stayed...there's a sign on the door saying so. 'Wilfred Owen stayed here 1917 - 1918.' I pass it every day. You *know* that. |

| Gran | It's haunted that room Freddie...when you're |

done, come on down and I'll show you something I bet you've never seen before.'

Freddie OK Gran, maybe Wacky Wilfy's ghost can tell me why we keep on going to war then? That would be something useful at least. Wouldn't it? And don't fret so much - I'll be down in a minute.'

(Sound of creaking floorboards, a door opening.)

Scene 3

('Owen's Room;' dark with lights showing Gran, white haired, dressed in a white flowing dress surrounded by swirling white smoke, ethereal... deep, dark voices booming from opposite sides of the room. Freddie looks on from the landing. Both are in a rigid dreamlike state...)

Voice 1 Bent double, like old beggars under sacks,
 Knock-kneed, coughing like hags, we cursed through sludge,

Voice 2 Till on the haunting flares we turned our backs
 And towards our distant rest began to trudge.

Voice 3 Men marched asleep. Many had lost their boots
 But limped on, blood shod. All went lame: all blind

Voice 1 But someone still was yelling out and stumbling
 And flound'ring like a man in fire or lime

Voice 2 Dim through the misty panes and thick green light
 As under a green sea, I saw him drowning.

Voice 3 In all my dreams, before my helpless sight,

He plunges at me, guttering, choking, drowning.

(*A distant door slams*)

Roxanne (*off*) Hello upstairs, are you finished yet, what's going on up there, I thought I could hear voices, are you al right Freddie...where's your gran gone?

(*Freddie and Gran emerge from their rigid dreamlike state. Gran pushes Freddie out.*)

Gran Stop all your dreaming Freddie, I don't know what ever comes over you. Now do your coursework, I want a quick chat with Roxanne - we'll only be a minute and when you're finished you can play your silly little games ...it won't take long... whilst it's fresh... (*voice trails off...exit Freddie as Roxanne enters...*)

Scene 4:

(*An empty kitchen, Gran and Roxanne sit down at a kitchen table.*)

Gran Roxanne, dear, I need your help. Freddie's falling behind in class; the teachers say 'e isn't doing any homework and 'e got himself excluded last week...me and 'is mum are worried...any ideas?'

Roxanne I've been thinking about it too Mrs Wright, he just doesn't get it... not at all and now he's started messing up the class; acting

strange, swearing and coming out with some pretty wacky stuff. The teacher's right fed up with it I know...I'm right fed up with it actually...I was wondering if... well... maybe there was any family link to some specific event from the past - to the First World War perhaps that might help his over-active imagination? It's such an important part of the course - all the causes of conflict...that's why we do so much on it...but Freddie won't listen-says it's all a load of...

Gran ...well, there's a few medals from the Boer War in the box room upstairs and a photo or two...nothing else much but...wait a minute...

Roxanne What is it Mrs Wright...?

Gran Have you ever seen Freddie with that old metal engine on the stand...?

Roxanne ...the one with the wheel on the side, a bit like an old Meccano toy like you can see down in the museum?'

Gran Yes, that's the one, Freddie keeps it in the drawer by the side of 'is bed - I'm not sure why but 'e's very attached to it for some reason - always polishing it and messing around with the wheel and that... it's as if it somehow reminds 'im of 'is dad ; not that 'e cared very much...'

Roxanne Where did it come from?

Gran	It was passed down from 'is great grandfather - the one who was a soldier and fought in the Boer War; the one in the photo with all the medals, a right charmer he were by all accounts.
Roxanne	What happened to him?
Gran	...wounded at a place called Magersfontain in the Cape Colony during the Boer War or so 'is letters say - so bad it were that they sent 'im home - after the camp that was. 'e became a postman like his brother Arthur back in Scarborough. Bit ironic really as Arthur, who'd never seen a gun nor raised a word in anger, 'e was killed, peacefully delivering letters in Filey Road during the Bombardment. And there was our 'enry,' a right soldier through and through, survived. H'ornted 'e were; to 'is very dying day with what them writers call the 'vicious scars of war.'
Roxanne	The Bombardment? Was that when the German ships shelled the town in 1914; I've been reading about it.
Gran	Yes, back then was when they first realised that war had come to us, the people, in our 'omes - that now we would be in the front line just like them Tommie's in the trenches. Though maybe not so wet.' In fact the anniversary is this week - on Tuesday...'

| Roxanne | Well, maybe we could find a link-I could ask the scout leaders tomorrow - see if they will help-we could find out all about Freddie's great granddad and drag him along, Freddie I mean, it's parade night on Tuesday with everyone there - he won't refuse if it's all about him'. |

Scene 5:

(The Church Hall just before the performance begins...)

| Roxanne | It's ok, Freddie, You're not on 'til later-after everyone else has done their skit - each group has five minutes and then it's you, I'm the *compere* for tonight so just hang in there babe you'll be great; you see if you won't... |

| Freddie | Yeah, whatever... |

(The stage lights up)

| Roxanne | My Lords, Ladies and gentlemen, boys and girls, it is my very great pleasure on behalf of everyone involved in this Community to welcome you to our all-star review performance of 'One Day in December.' You are going to be treated to a stunning array of talent to night. What now follows is a number of short sketches written and arranged by the young people of the community so please give a huge roar of welcome to our first act: |

(The sketches begin.)

[In the first performance of *'One Day in December'*, five sketches were devised, written and performed by the uniform youth organisations of Westborough Methodist Church, Scarborough that made up the cast of the show. In community theatre we felt that what was so devised would be what was produced unless the content was deemed unsuitable or offensive. The sketch scripts as written by the young people are reproduced here purely by way of example.]

SKETCH ONE: 'THE UNIVERSAL SOLDIER'

Narrator

Good evening. I am the narrator *(bows)* and in this sketch we have:

Doctor Matthews, a junior doctor *(bows)*

Doctor Thomas, another junior doctor *(bows)*

Corporal Dylan, an injured Soldier *(bows)*

Soldiers, wounded. As I said...and... *(they bow)*

Stretcher bearers. Thank you. (*Applause... Bows*)

Narrator

Scene One: A beach. *(Sound of crashing seas)* A soldier lies injured amongst the sand and rocks. Two doctors arrive on the scene.

Corporal Dylan

Aghhh, help me doctors, at last, I'm saved. Water ...water...

(...loud crashing sea sounds)

Doctor Thomas

Quick, Doctor Matthews, over here. Its Corporal Dylan...he's been hit by shrapnel by the looks of it. He's in a bad way...

Doctor Matthews Right, I'm coming...but there's more wounded soldiers over here...it looks like they were caught by surprise...

Narrator Other casualties are seen, moaning and groaning in agony...

(Other casualties moaning and groaning in agony)

Corporal Dylan Help me quickly come on...I'm badly hurt...

Narrator The doctors help the wounded Corporal Dylan.

(Sounds of crashing seas)

(Doctors check the Corporal and the other soldiers for wounds...rising sea sounds)

Doctor Thomas We're going to have to take him to hospital, he's in a really bad way. Call the stretcher bearers,

Doctor Matthews Stretcher bearers, stretcher bearers... *(Ambulance* bell) The ambulance is coming, let the stretcher bearers put him in.

Narrator An ambulance arrives. Two stretcher bearers come out and carry the wounded soldier off to the ambulance.

Two stretcher bearers pick up Corporal Dylan and carry him off to the am-bulance. He screams.

Narrator Scene Two; Westborough Emergency War Hospital. There are a number of injured soldiers lying in beds. Two

stretcher bearers bring in the wounded Corporal Dylan.

(Stretcher bearers bring in Corporal Dylan still screaming...they place him on a bed)

Doctor Thomas Where does it hurt Corporal Dylan?

Corporal Dylan It hurts in my arms...in my legs...in my head...in my belly...aghhhh

Doctor Matthews Umm, that sounds bad...I think we're going to need lots of bandages what do you think Doctor Thomas?

Doctor Thomas I think you're right Doctor Matthews... *(starts to bandage)*

Corporal Dylan I'm fine. I'm fine. Leave me alone...I will be alright...

Narrator Or not...

Doctor Matthews If that's his attitude, let's go back to the beach and look at the other wounded soldiers... *(they depart)*

(Corporal Dylan off stage puts on a dress made from bandages)

Narrator Two hours later...by the beach...

(Enter doctors)

Doctor Thomas Be careful there might be more shells coming over...

Narrator One hour later...still by the beach

Doctor Matthews Let's check over here...I thought I heard screams.

126

 (Pause) ...I said I thought I heard screams...

Narrator He said he thought he heard screams

(Sound of screams off)

Doctor Thomas You did...

Narrator He did...

(Exit Doctors)

Narrator Scene 3 In the hospital...one week later

(Bodies lying on sleeping bags in ordered lines, one is Corporal Dylan, heavily bandaged all over preventing speech)

Doctor Thomas Now then Corporal Dylan, are you feeling better?

Corporal Dylan mmmmmmmmm ugggghhhhh mmmmmmm

Doctor Matthews We didn't quite catch that....

Corporal Dylan mmmmmmmmm ugghhhhhhh mmmmmmm

Doctor Thomas No. not that time either, try again...

Narrator Are you doctors deaf as well as daft...he said
 mmmmmmmm ughhhhhhh mmmmmmmm anyway
 there's a telephone call for you from the War Office...

(A Telephone rings...)

Doctor Thomas Yes, yes I think I understand, it's a terrible line...did you

say the war is over.....?

Doctor Matthews and Narrator The war's over??? Yippeee hurray
hurray, *(they dance about...)*

All soldiers (They rise throw off their injuries and dance...)
The war's over, hurray, hurray yippee...

(Music starts they all sing words on screen...)

Narrator Hurray! The war's over and it's not even
Christmas... Altogether now....
 (they sing with audience...)
 Pack up your troubles in your old kit bag...

(As the music plays the sketch cast wave and depart stage...)

END

SKETCH TWO: 'ANTHEM FOR DOOMED YOUTH'

Roxanne Thank you thank you; that was the 46th Westborough
Cobra Cubs; unfortunately, of course the war wasn't
over by Christmas 1914 as everyone had hoped...did
you know that this very church was indeed actually a
hospital for the Bombardment and then throughout
the war...? I didn't either but it was...
Wasn't the sketch performed brilliantly? Thank you
everyone...our second act is called **'Anthem for
Doomed Youth'** a change of mood to a more sombre
reflection on the effects of war based on the poem by
Wilfred Owen performed by the cast and members of
the Westborough community.

(A deep bell sounds, mournful and slow...slow quiet music is heard...the dim lights reveal the bodies of soldiers lying still across a forlorn field...a voice is heard from above...)

Owen What passing bells for those who die as
 cattle
 Only the monstrous anger of the guns
(gun and rifle fire is heard in the far distance)
 Only the shattering rifles' rapid rattle
 Can patter out their hasty orisions.

(A moment of silence then the opening bars of 'Scarborough Fair' are heard...enter 'pall bearers' scouts, guides, brownies, cubs slow march/walk some with LED candles, as they enter a lone voice above sings three adapted verses of Scarborough Fair...)

(Gran) Are you going to Scarborough Fair?
 Parsley, sage, rosemary and thyme.
 Remember me to one who lived there.
 He once was a true love of mine.

 Tell him to find me an acre of land.
 Parsley, sage, rosemary and thyme
 Between the sea and over the sand.
 Then he'll be a true love of mine

 Plow this land with the horn of a lamb.
 Parsley, sage, rosemary and thyme
 Then sow some seeds from north of the
dam.
 Then he'll be a true love of mine.

Owen No mockeries now for them, no prayers,
 nor bells
 Nor any voice of mourning save the choirs

(cast join quietly with chorus in background...)

All Are you going to Scarborough Fair?
 Parsley, sage, rosemary and thyme.
 Remember me to one who lived there.
 He once was a true love of mine.

Owen The shrill demented choirs of wailing
 shells

(sound of shells and battle in the far distance)

Owen And bugles calling them from sad shires.

(The last post sounds above the low singing of the chorus, a lone cornet player is lit on the battlements)

Owen What candles may be held to speed them all?

(Bearers place their lit LED candles by the left hand of each dead soldier...)

Owen Not in the hands of boys but in their eyes
 Shall shine the holy glimmers of goodbyes
 The pallor of girl's brows shall be their pall

(Opening bars of 'Chanson de Matin' sound faintly in the distance... the dead rise with their candles in their left hand, their right hand placed on the shoulder of the one in front as in a line of gas blind weary soldiers from the trenches...they exit stage right slowly up a flight of steps as if to heaven...their hands dropping, the candle lights put out...)

Owen Their flowers the tenderness of patient minds
 and each slow dusk a drawing down of blinds.

(...a ballet dancer enters, salutes the spot lit flags and performs a dance solo to 'Chanson de Matin'... ends, the lights dim and the scene ends.)

Roxanne Thank you, thank you what a truly wonderful and
 moving performance that was...I shouldn't think
 there's a dry eye in the house but wipe away your
 tears as we invite you to another change of mood
 because ...

SKETCH THREE: 'SONGS FROM THE FIRST WORLD WAR'

Roxanne

(Enter all cast members for the Old Time Music Hall...walk across stage to the alter stage area, turn and face screen, stood casually...)

 ... now it's your turn...for our third act we invite you to
 join the bands and musicians for a delicatessen of
 delightful decibelisations *(bangs gavel)* in our Old
 Time Music Hall 'Songs from the First World War'... led
 by our very own Director of Music Mr Mark Gay ac
 companied by Mr Michael Bull and the band...take it
 away maestro...

(words appear on screen)

Medley 1	Good Bye Dolly Gray	All, led by Mark Gay
	Good byeeee	All, led by Mark Gay
	Roses are shining in Picardy	(Solo Mark Gay)

Take me back to dear old Blighty (led by Mark Gay vocals, Michael Bull keyboards)

Medley 2 I'll be your sweetheart (Mark Gay vocals, Michael Bull keyboard)

Daisy, Daisy (Mark Gay vocals, Michael Bull keyboard)

She was a sweet little dicky bird (Keyboard and Vocals Mark Gay)

My old man said follow the van (Miichael Bull, Mark Gay vocals)

Medley 3 (Mark Gay) Let me call you sweetheart
If you were the only girl in the world
Keep the home fires burning
Pack up your troubles in your old kit bag

Michael Bull solo keyboards arrangement, accompanied by Ann Bull and the band...

SKETCH FOUR: 'REMEMBER SCARBOROUGH'

Roxanne Thank you, thank you, wonderful voices everyone...and now without further ado we move onto our fourth act and we are transported back in time once again to 'Remember Scarborough' performed by the 46th Westborough Scouts, 2nd Guides, Brownies and Boys Brigade...

(lights down, dawn breaks…two soldiers are sleeping, one enters from sentry duty at the electric works)

Corporal	Wakey, wakey, rise and shine you lazy soldiers. It's a cold morning out there and guess what? Only nine more shopping days to Christmas.

(He shakes the soldiers awake…)

1st Soldier	OK, OK we are getting up aren't we corporal…and where's my cup of tea in bed anyway…

2nd Soldier	And mine…

Corporal	Call yourselves soldiers? You're only fit to guard these electric works where, thankfully, there is absolutely no chance of you having to fight the Germans is there? One look at you two and the deadly old Hun would be over here in a jiffy…

(Sounds of explosions and shells landed everywhere…)

1st Soldier	What was that?

2nd Soldier	And that?

(1st Soldier goes to look from the window.)

Corporal	The deadly Hun must have seen you two - he's here! Quick, take cover!

(Exit soldiers at the double)

(Explosions, light, smoke...the lights come up to show wounded women and children in the Westborough Hospital waiting room, groaning and writhing about. Nurses and matron moving about tending the wounded and doing first aid. Enter the soldiers, one injured being carried in by the other two.)

Matron

> Wow! Soldiers... we must help them...come on you nurses let's sort them out...Put him down here you men.

1st Nurse

> What do we do Matron?

Matron

> Where is your training nurse? Who knows what we have to do first?

Voice (of Sister Roberts) Wash your hands....

Matron

> Who said that...?

1st Nurse

> Uhhhhhh...help!

2nd Nurse

> I didn't hear anything...but it *is* a bit creepy down here isn't it?

(Smoke eddies about...soldiers groaning and shaking with fright...)

1st Nurse

> I think a cup of tea all round might help...

Voice

> Wash your hands nurse...

2nd Nurse

> Alright Matron, keep your hair on...

Matron

> Pardon?

2nd Nurse	I heard you the first time, I *am* washing my hands…
Matron	What are you talking about nurse I never said anything about your hands…
1st Nurse	O no, I tell you this place has a ghost
Voice	Thank you! Now don't be afraid girls I am a ghost but a friendly ghost….here to help you …all you have to say is the password 'ghost' and I appear, simple as that… it's just like Alexa[1], that's how things will be in the future …never you young things worry about that though, we oldies will teach you all you need to know… you'll soon catch on. If you have a patient and you don't know what to do you just say 'Ghost' and I tell you what to do…let's try it…you tell me what you're stuck with and I'll tell you the answer…
1st Nurse	Alright. Ghost. This soldier's been hurt in his legs…
Voice	The answer is…chop them off
1st Nurse	Chop them off but it's only a small cut..
2nd Nurse	What about this soldier then…he's hurt in his arms…
Voice	The answer is…chop them off…
2nd Nurse	Chop them off? But it's only a splinter of wood…
Matron	Well, what about this soldier then…. he's hurt his

[1] In the original production the word 'google' was used; 'Alexa' being an alternative but equally appropriate version.

head....no don't tell me Ghost; chop it off...

Voice No, don't be so silly, leave the head...just chop
 his body off...

Soldiers No....get us out of here....we're fine...we're fully
 recovered...it was nothing...really it wasn't....sorry to
 trouble you...

Matron Well I'm not sure that google thing is the way forward do
 you nurses...?

Nurses No, no, the old ways are best...

Corporal Thank you Matron you and your nurses have all been so
 very kind. We'll be as right as rain soon I'm sure. We
 want to thank you; and me and my mates think you need
 a tune to help you on your way.

(They play some 'Ghost music' music and everyone sings...) End.

SKETCH FIVE: 'THE LOST SCOUT'

Roxanne Thank you and now for our next sketch we have
 the true story of local boy scout, 15 year old George
 Harland Taylor, one of two scouts hit by shellfire in
 'The Bombardment'...The scene opens with George
 and his friend Jez preparing for a concert.

(Enter George and Jez carrying guitars onto the top stage, they strum and tune...)

George You nervous Jez...?

Jez	Yeah sure it's not every day we get to perform to this many people is it?

George	Just think though - we are the finalists in the District Scouting Music Championships. And we're in the best position - we're last on so the judges will remember ours the most won't they?

Jez	Yeah and the press are here too…we'll really show them…I do feel a bit sick though…

George	I know what you mean…in the stomach - imagine what it must be like waiting to go over the top in the trenches…they must be really sick all over the place… glad I'm not old enough to go to war…

Jez	Yeah , me too but don't go on any more you're just making it worse…look here comes the D.C.

(Enter District Commissioner)

D.C.	Ladies and gentlemen, boys and girls. I am the District Commissioner of the local scouts and the host of this year's Scout Music Championships 1914. Tonight is the last of the six weekly rounds and we've had some great performances this year, haven't we? We have had everything from euphoniums to ukuleles and now we have two young talented scouts from 46th Scarborough here at Westborough who are going to perform the last entry. The winners will be in the paper tomorrow and they will go on to the national championships all the way down in London; Zeppelins permitting of course. So, without further ado please welcome young scouts George Harland

Taylor and his friend Jez Jelfs….

(Applause…they play 'Keep the Home Fires Burning' and 'Somewhere we know…' followed by more applause)

D.C. Thank you thank you what stars they are…they surely have a great future ahead of them…as I said the winners from all the heats will be announced in tomorrow's Scarborough Gazette….thank you all very much…

(Lights dim and rise showing Connie, George's Mam sitting at the breakfast table ironing…knock on the door… enter Jez)

Connie Taylor Hello Jez, you recovered from the competition last night then? Results due very shortly now aren't they?

Jez Hello Mrs Taylor…yes but it feels very strange out there in the street… it's eerie like and sends shivers down my back…strange feeling really…like before a storm… or someone watching you…

Connie Nay lad that's just nerves waiting for the results …George's gone down to Mr Morley's shop to buy a newspaper- he won't be long, he reckons you're the winners after last night's show - you were fantastic.

(She sings quietly as she irons… 'Keep the Home Fires Burning'…Jez picks up George's ukulele and plays a few bars of 'Somewhere I know…')

(Sound of thunder…)

Connie You were right about it feeling strange this morning…hark at that thunder

(Explosions around the kitchen...smoke...they emerge looking dishevelled...)

Jez It's not thunder Mrs Taylor, it's the Germans...we're being shelled...quick...hide under the table...Where on earth's George got to...*(they hide)*

Connie and Jez (emerging from under table) George...George.... *(They search around)*

Connie George, George...

(Jez finds a body clutching a newspaper lying in smoke nearby. He runs over...lifts George's head...)

Jez Quick, Mrs Taylor over here...its George...he's been hit....

(They crouch by George's side and lift him up to sitting position...he waves the paper triumphantly above him...)

George It's in Mam, look...we won...we won...

Connie Oh my God.... *(silence as she cradles him, rocking gently...)*

Jez He's gone Mrs Taylor...but he went knowing we'd won... that was a blessing... it was all he wanted...he's in a better place now...

(Jez picks up his ukulele and plays some bars of 'Some where I know...'lights dim music stops)

Connie George was the first scout to die in the First World War but

he wasn't to be the last...the Boy Scouts went on to do vital war work, carrying messages, patrolling to spot mines off the coast and incendiary devices dropped by Zeppelins, helping in field kitchens and in hospitals...many became telegram boys and delivered the awful messages from the front...they were all heroes and today our scouts carry on the fine tradition of service and sacrifice that the war time scouts performed so well. So, if you want to help carry on the tradition by becoming a leader, a volunteer or a scout please 'Remember Scarborough! And join today! Your scouts need you! Thank you all so much.

Roxanne Thank you the 46th Scarborough (Westborough) Scouts... another really moving performance and lovely music...John Lewis[2] just won't seem the same again

now...

And now for our final act we have Mr Freddie Wright on The Static Wilson Engine 1865 come on down Freddie Wright...

Enter Freddie, Places engine from being neatly tucked under his arm carefully on the table...waits for audience to quieten.

Freddie My dad gave me this, it's a model of a Static Wilson Engine, it's over 100 years old and it was made by my great, great, granddad. See all this bare metal... the shiny bits-they're made of old shell cases that he was given by the Boers when he was in a camp hospital....this one's the main piston...it was made from the bullet the doctor took out of his leg...the doctor told him to

[2] *'Somewhere I Know'* was that year's John Lewis Christmas TV music.

look after it so he'd remember how lucky he'd been and he put it into this engine. I've been really moved by all these performances here tonight and I reckon my great, great grand dad was trying to tell me something with this engine...maybe history is important...and biology and geography...something about all the sacrifices they made...I'm going to take this engine into school tomorrow and shake them all up a bit...

Freddie sits, Roxanne jumps up and places a seductive kiss on Freddie's lips, gran hugs him firmly from behind. There is loud applause.

Roxanne Thank you everybody once again, to the leaders and all the young people; It's been such a great night...if Wilfred Owen himself was here he would have loved all this I'm sure...

(Flashes, lights, noises of bombardment... from out of the smoke an ethereal figure rises...)

(Cries of surprise...)

(Ghost of Wilfred Owen rises from far below in a lift, clouded in smoke, green light and eerie music...playing softly...)

 Bent double, like old beggars under sacks,
 Knock-kneed, coughing like hags, we cursed through sludge,
 Till on the haunting flares we turned our backs
 And towards our distant rest began to trudge.
 Men marched asleep. Many had lost their boots
 But limped on, blood-shod. All went lame; all blind;
 Drunk with fatigue; deaf even to the hoots

Of tired, outstripped 'Five-Nines' that dropped behind
Gas! Gas! Quick, boys! - An ecstasy of fumbling,
Fitting the clumsy helmets just in time;
But someone still was yelling out and stumbling,
And flound'ring like a man in fire or lime...
Dim, through the misty panes and thick green light,
As under a green sea, I saw him drowning.
In all my dreams, before my helpless sight,
He plunges at me, guttering, choking, drowning.
If in some smothering dreams you too could pace
Behind the wagon that we flung him in,
And watch the white eyes writhing in his face,
His hanging face, like a devil's sick of sin;
If you could hear, at every jolt, the blood
Come gargling from the froth-corrupted lungs,
Obscene as cancer, bitter as the cud
Of vile, incurable sores on innocent tongues,
My friend, you would not tell with such high zest
To children ardent for some desperate glory,
The old Lie: *Dulce et decorum est*
Pro patria mori. *Silence as...(suggested)*

(...the lone voice of Gran accompanied by a guitar starts to sing Scarborough Fair...the performers enter at a slow march down each of four aisles, heads bowed until they circle the stage...when all halted and the last one arrives, they turn and face inwards. At the sound of a school hand bell they hold hands and start to sing....'Don't know nothing about geography...' leading into upbeat marching songs from the First World War to which they dance off... Good Byeee reprises etc...enter Roxanne...)

Roxanne Ladies and gentlemen our show has come to an end
so please will you welcome back onto the stage your
cast.... *(exits and returns as last on...)*

Chapter 6:

Community Theatre: Production Notes

We, as directors and producer, found producing this piece of 'Community Theatre' to be both challenging and rewarding and felt there would be benefit in explaining a few of the steps we took and some of the potential pitfalls we came across in this chapter. They are by no means the only issues but these are the main ones relevant to this production and work.

From the start, there were a number of separate actions that needed to be taken to engage the community, by far the most difficult part of the whole enterprise.

- Once the decision had been taken to embark on the community theatre project then how to reach out to the community became the priority. For *'One Day in December'* we were working to a tight deadline because of the agreement to provide the play as part of the Scarborough Literature festival 'Fringe' for that year. This meant we only had 10 weeks to complete the whole project from start to finish.

We felt we needed a homogenous group to work with; members of the community who were already based at one place with some semblance of existing cohesion. An approach to the Outreach Department at the Stephen Joseph Theatre (Denise Gilfoyle at the time) sent us onto Westborough Methodist Church where many staged productions

take place due to the exceptional acoustics and the 'theatre in the round' seating configuration. There the minister at the time, the Reverend Mark Haynes, readily agreed not just to the use of the church but to approaching the uniform youth groups attached to them. It proved to a truly exceptional venue.

- Considerable resistance was met at first from which we learnt of the importance of both time and a full written and pictorial brief for the groups to consider; neither of which we had. We were eventually able to overcome much of the resistance, but for success it is absolutely essential to have the full and willing engagement not only of the group themselves but, with young people, the full support of their parents or guardians. The demands on young people today are high leaving them little time for extra-curricular activities during term time. The demands on their parents and guardians can be even more so. Some of those involved were single parents or guardians looking after children under very disadvantaged circumstances. This became a real dilemma; should the youngsters be denied the opportunity to perform on a public stage when they were really keen to, because their parents and guardians were too pressured to fetch and carry them from the venue for the rehearsals and performance itself? We decided the youngsters were so keen to perform that we would do everything we possibly could to make sure they did so. In a few cases this was against the wishes of the parents but we persevered and, in the end, even the reluctant ones saw the benefits that were gained.

- Once the cooperation had been secured it was a 'five nights a week' matter of visiting each separate group and laying out the requirement. Working in groups, the uniform members devised, researched and designed their sketches, being guided throughout by the directors as to the overall theme and concept. We felt that In community theatre such as this 'what the community writes is what should go'; it is their production and whilst

there needed to be a strong element of editorial and technical help, the idea was for those participating to learn about many things; all aspects of theatre, how to conduct research, how to use a library, how to write basic scripts, how to work collectively and collaboratively, how to give and take, how to resolve conflicts, how to persuade without being a bully and how to be the best they possibly could be – being confident, believing in themselves. The list of wonderful benefits went on.

- Once the sketches had been finalised and agreed then rehearsals and costume fitting took place. This was one of only two occasions when the directing staff nearly came unstuck over youth engagement 'Safeguarding' protocols. None of the directing staff at the time had what is now called DBS clearance; it wasn't felt necessary because we were never to be alone with the youngsters; there was always a uniform youth adult present. But at the costume fitting with the wonderfully talented and very experienced theatrical costume maker, Felicity Stevenson, the two directors were working on both sides of the rehearsal area with a doored corridor between. In a slight mix up in communication a youngster, a girl, was sent to change in the corridor not being aware that it was already in use by an adult male. Thankfully she was aware of the potential for danger and turned straight round and out again. Such productions are not without their challenges but the need for 'Safeguarding' must always be paramount. (The second potential safeguarding issue occurred on the night of the performance itself when one of the actors was involved in a brief 'upset' in the Green Room just before he went on stage. He shrugged it off and bravely went on stage nursing a sore lip. These things happen.

As the rehearsals progressed so ticket sales were encouraged; the venue could hold around 250 people which we thought would be difficult to fill. In the end we half-filled with 125, a fact we put down to a mixture of engagement issues with some of the parents involved and generally insufficient time throughout; especially for marketing. We learnt that a

community production of this scale and magnitude requires a full year of preparation and engagement; rather more than the 10 weeks we had provided.

What did we learn? Firstly, we, as the directors, soon realised we had bitten off more than we could easily chew. What had started off in concept stage as a 'four-hander'; a straight forward play with four actors, had ended up as a major theatrical event with a cast of 120 people. We learnt much about the nature of Community Theatre; how important it is to embrace all those who wish to be involved. To deny young people opportunity is definitely *NOT* part of the game and we needed to be ready for this. Given the severe limitations of no budget whatsoever and relying on programme and ticket sales, the latter of which had already been set at £3 by the festival fringe committee, meant we needed sponsorship; an aspect which took time and effort to secure. We were immensely grateful to the sponsors and they are duly acknowledged here;

Angela and David Chalmers, Woodend Creative Workspace,

Crescent Wealth Management,

Scarborough Museums Trust Britannia Hotels,

Scarborough Maritime Heritage Centre,

Dunslow Road Vets, Scarborough, the Western Front Association,

'Scarborough Flare', Bryn Stowe Associates,

Prontaprint, Scarborough.

A huge thank you to them all without whose help we would never have achieved what we did.

In the programme I felt the need to explain that there were two Latin derivations that might benefit from translation. In *'Anthem for Doomed Youth'* the word 'orisons' means prayers or reverent petitions to a deity or deities and is a word out of common use these days. In *'Dulce et Decorum Est'* the last two lines in Latin can be translated as 'It is sweet and honourable to die for one's country.' This line, from an ancient poem by Horace, adorned the walls of the Royal Military Academy Sandhurst; hence Owen's words of exposure; 'the old lie...' I added these to the programme because I felt many of those involved were youngsters and it might help them to feel an understanding of the work and to be fully involved as 'a team' in what we were doing.

The Essence of 'Team'

Possibly the biggest single element of success in this endeavour was the creation of 'team'; that feeling of a group of people belonging to each other and supporting each other's endeavours through thick and thin. We, the directors, felt that the better the creation of a team ethos the more successful the final outcome was likely to be. Creating successful teams is a skilled art form in its own right and relies on 'transparency of purpose' and action as well as effective communication. Could every single person involved believe in what was being undertaken? Could they commit to it? Not because someone told them to, but because they really believed it was important as a whole and that their part in it, however small, was of vital importance to the achievement of that whole.

With *'One Day in December'* we, as a theatrical company, were largely successful with the young people themselves in achieving a sense of 'team togetherness' with them, but we failed really to embrace *all* of the parents and guardians. Had we done so it is probable that, not only would we have had a much smoother journey, but we would have completely filled the hall; the youngsters and everyone involved all deserved for that to be so. It was an important lesson learned.

Gallery: Cast Rehearsal Photographs

Fig 60: The actors and producer at Woodend during rehearsals.
(Cast photos by Callum Nash)

Fig 61: Evie Stanway who appeared in the sketch 'Anthem for Doomed Youth'

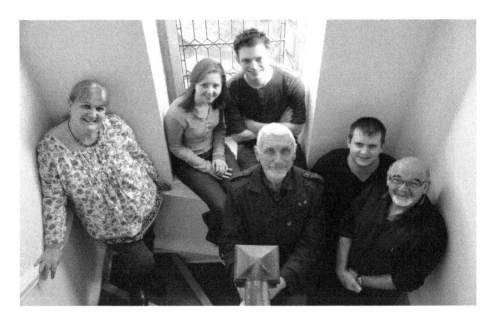

Fig 62: Cast members at a 'tech' rehearsal at Woodend.

Fig 63: Bill Hammond (Wilfred Owen) rehearsing his arrival on stage.

Fig 64: The producer.

Fig 65: Jen Davis (Roxanne) and Mark Palmer (Freddie) rehearsing their lines.

Fig 66 & 67: Barbara Halsey (Gran) and Mark Palmer (Freddie) in rehearsal.

Fig 68: Professional actor and director, Lucy Lowe directing rehearsals.

Fig 69: Music rehearsal with Mark Gay and the musicians.

The Original Cast

Barbara Halsey (Gran)

Fig 70: Barbara is a trained actor and writer who was living in Scarborough at the time of the first performance. She had performed with various theatre companies, in various locations and in a variety of roles. Her past performances included the role of Hera in Steven Ayckbourn's *'Paris Fashions'* for Scarborough Actors and Writers. She had performed many times with Scarborough's Beach Hut Theatre Company where she also worked as a writer. Other local companies include Attic Theatre Company and STAMP. In her many years performing in Oxfordshire her roles included Nora in Ibsen's *'A Doll's House'*, Sheila in Alan Ayckbourn's *'Relatively Speaking'* and Kattrin in Bertolt Brecht's *'Mother Courage'*. Barbara had performed in almost 50 productions including many leading roles and was also a successful drama workshop facilitator, a very different, but equally satisfying role.

Jen Davis (Roxanne)

Fig 71: Jen started her performing career as The Prince in *'Sleeping Beauty'* at the tender age of 6 before moving up through a range of dance workshops to primary and high school drama productions. She eventually completed a BTEC National Diploma Performing Arts course in musical theatre. She was completing her third year BA (Hons) course in Performing Arts at The University of Hull

at the time of the production. During her time in Scarborough she took part in a range of local performance including the YMCA Christmas panto, the Easter variety show and as Patty Simcox in the acclaimed YMCA production of *'Grease'*. Her last role before the production was as 'Major Roadworks' in *'Sleeping Beauty'*, again for YMCA. Jen continued her theatrical career and at the time of publication was a dresser at the Birmingham Repertory Theatre.

Mark Palmer (Freddie)

Fig 72: Mark began his stage career at the Westwood Performing Arts Course in Scarborough aged 15 and has since performed regularly across Scarborough. His credits include; Herr Veller in *'The Sound of Music'*, Marcel in *'The Boyfriend'*, Desmond Taylor in *'Mack and Mabel'*, Roger in *'Grease'*, Mad Hatter in *'Captain Cook'* and many more. Companies he has performed with include; Scarborough Musicals, Phoenix Theatre, STAMP, Cresta Players, Spotlight, YMCA, Footloose and in film he appeared as a prison chef in *'Screwed'* for Cake One Productions. His appearances also include an apostle in *'Jesus Christ Superstar'* at the YMCA. He has also acted as a stage manager in *'Animal Farm'* at the Westwood and has appeared at the Stephen Joseph and Futurist Theatres in Scarborough. Mark is also a trained fight arranger for stage productions.

Bill Hammond (Wilfred Owen)

Fig 73: Bill is a well-known local poet in the Scarborough district and regularly hosted poetry slams and open mics. He was the Chairman of the Scarborough Poetry Workshop at the time of the production and was busy organising the 'Century

of British Poetry' at the Art Gallery. He also hosted the Poetry Slam at the Old Vic for that year's Scarborough Book Festival. He is an accomplished writer, storyteller and actor and made his debut appearance as Wilfred Owen for TAFAT.

D. B. Lewis (Producer)

Fig 78: David began his theatrical career behind the scenes as a prompt,

stage hand and review producer. In later life he quickly progressed to acting directing and co-producing community pantos including *'Aladdin'* and *'Jack and the Beanstalk'* at the Yew Tree Theatre, Harrogate. In 2006 he launched the *'Streetbeatz Programme'* using Forum Theatre and Djembe Drumming to reduce tensions between the police and young people in local communities. David later went on to co-direct internationally known stars such as Kellie Bright and Charlie Foloronshu. In 2011 David directed *'Beauty and the Beast'* for the Cloughton Village Fund Annual Production before co-founding TAFAT with local Scarborough actor and writer Barbara Halsey in 2013.

David is now a full-time writer under the name 'D.B.Lewis' and has published a number of books including; *'A Little Bit of Trouble in London'*, *'Plotting Shed' (Ed)*, *'Great Aunts and Armadillos'*, *'Return to Premantura'* and *'A Wedding in Hvar'* as well as *'One Day in December'*. David is also chair of the International Police Association Writers' Forum and a Literacy Champion for the National Literacy Trust. His literacy project *'Stories for All'*, using a Police liveried Morris Minor 1000, is proving very popular in inspiring young people of all ages to write stories.

Lucy Lowe (Director)

Fig 79: Originally from Scarborough, Lucy is a well know British actor who has appeared in many TV shows and films such as *'Emmerdale'*, *'Hollyoaks'*, *'Worried About the Boy'*, *'Doctors'*, *'Hard Shoulder'*, *'Debbie'* and others. Another recent role was in the feature film *'Blood'* with Paul Bettany.

She has toured nationally playing the lead female role in *'Columbo: Prescription Murder'*, opposite Dirk Benedict and Patrick Ryecart. She had lead roles in *'The Lonely Clouds of Guernica'* and a sell-out run of *'Eight'* at the Lowry which she co-produced.

Lucy is also a professional Voice-Over artist and has voiced national campaigns and commercials on TV and cinema. She has been a guest director for students at ActUpNorth Acting School on a number of different occasions. She has extensive directing experience and made her West End acting debut in 2019.

Lucy's first feature film as a director, *'Uncle Art'*, a documentary about her father Dave Lowe's journey as a leading producer of music for the 'gaming' genre, was released in 2019 to popular acclaim.

Mark Gay (Music Director)

Fig 80: Mark had a long and successful career in professional music including performing on the world cruise of The QE2. He was the founder of the 'Cloughton Rat Pack Big Band' and was a very talented keyboard player and singer. He was well

known in the Scarborough area as a performer and appeared at the town's mayor making ceremony at the Town Hall. He regularly entertained at many venues including residential homes in the area, clubs and for special events by arrangement. He helped raise thousands of pounds for St Catherine's Hospice in Scarborough and TAFAT were honoured to have him arrange and direct their music. Mark sadly died from Parkinson's Disease in 2018.

Rob Webb (Technical Director)

Fig 81: Rob started his stage technical work whilst still at Scalby school in Scarborough and for many years worked as an amateur sound and lighting engineer for several local theatrical companies in Scarborough including YMCA, the Stephen Joseph Theatre and The Spa Theatres. He is the technical officer for Burniston and Cloughton Village Hall and has directed the technical scripts of nine highly acclaimed annual productions as well as a host of variety, big-band and other theatre work for a number of local companies. His resourceful and creative contributions to all his productions is a valuable asset.

Will Brace (Electronics Engineer)

Will is a gifted electronics engineer and has worked together with Rob Webb on many productions over the years. He specialises in the 'thrills and spills' side of production and is highly qualified in his profession. In '*One Day in December*' the team were responsible for a range of special effects including a recreation of the Western Front using smoke generators, strobe lighting and incredible sound effects.

The Cast List of the First Performance of 'One Day in December'

Freddie Mark Palmer

Roxanne Jen Davis

Gran Barbara Halsey

Wilfred Owen Bill Hammond

Musicians

Piano Mark Gay
Keyboards/Harmonica Michael Bull
Cornet Sean Mould
Saxophone Catherine Waddington
Guitars/Ukuleles Will Stanway, Hugh Stanway
Additional piano Matthew Wilson, Luke Wilson

Scene 1 Flag Bearers

1. (Scouts) Will Stanway
2. (Guides) Jessica Cornell
3. (Cubs) Dylan Jarrett
4. (Brownies) Katherine Kinsella
5. (Boys Brigade) Sean Mould

Scene 2. (Dogfight)

English Fighter Pilot Rory Ruston
German Fighter Pilot Damien Quinton

Scene 3. (Poem)

Voices. Members of Westborough 'Explorers'

Sketch One: ('Universal Soldier')

Narrator	Bobbie French
Doctor Matthews	Matthew Hancock
Doctor Thomas	Tom Brecken
Corporal Dylan	Dylan Jarrett
Wounded Soldiers	Rory Ruston, Damien Quinton, Matthew Wilson, Luke Wilson, Declan Mould
Stretcher Bearers	Hugh Stanway, Will Stanway,

Sketch Two: ('Anthem for Doomed Youth')

Pall Bearers	Hugh Stanway, Will Stanway, Rory Ruston, Damien Quinton Tiffany Taylor, Jasmine Birtwistle, Hannah Ritchie, Freya D'eath Libby Carney, Abbie Hick
Dead Soldiers	Dylan Jarrett, Tom Brecken, Matthew Hancock Matthew Wilson, Luke Wilson, Declan Mould
Last Post (Cornet)	Sean Mould
Ballet Dancer:	Evie Stanway

Sketch Three: ('Old Time Music Hall')

Director of Music	Mark Gay
Keyboards	Michael Bull
Tenor Recorder	Elizabeth-Ann Bull
Alto Saxophone	Caroline Stansfield
Ukuleles/Guitars	Hugh Stanway, Will Stanway

Cornet	Sean Mould

Sketch Four ('Remember Scarborough')

Corporal	Matthew Wilson
1st Soldier	Luke Wilson
2nd Soldier	Declan Mould
Matron	Tiffany Taylor
Nurses	Jasmine Birtwistle, Hannah Ritchie, Freya D'eath, Abbie Hick, Libby Carney
Wounded Soldiers	Dylan Jarrett, Tom Brecken, Matthew Hancock Rory Ruston, Damien Quinton
Ghost	Voice of Lilian Roberts

Sketch Five ('The Lost Scout')

George Harland Taylor	Will Stanway
Jez Jelfs	Hugh Stanway
Connie Taylor	Louise Stanway

We are grateful to Lynne Read from the Westborough congregation for permission to utilise part of this story in her novel based on the bombardment, *'Thunder in the Morning.'*

Production

Producer	David Lewis
Directors	Lucy Lowe/Barbara Halsey
Director of Music	Mark Gay
Technical Director	Rob Webb

Production Engineer	Will Brace	
Light/Sound Assistant	Katherine Kinsella	
Stage Manager	Martin Usher	
Technical Consultants	'Beanie'	
(Westborough)	Chris Widdowfield	
Choreography	Susan Richards	(Westborough)
Costumes	Felicity Stephenson	(Westborough)
Community Singing	Yvonne Jeffrey	(Westborough)
Marketing/Publicity Manager	Lisa-Marie Weetman	(TAFAT)

Publicity	Elsa Monteith, Callum Nash Wanda Machiusko, Sandy Sandevic,	
A/Stage Managers	Michelle Mulcahy	(TAFAT)
	Jo Kaye	(TAFAT)
	Jessica Cornell	(Westborough)
Green Room Managers	Norma Patrick	(Guides/Brownies)
	Fiona Kemp	(Guides/Brownies)
	Lorraine Dolben	(TAFAT)
Props	Arthur Healy	(TAFAT)
Historical Consultants	Len Friskney	
	Lynne Read	
	John Stafford	
	Joan Bayes	
	Lillian Roberts	
For Westborough Church	The Revd. Mark Haynes	

Elsa Monteith
Dr Roger Poole and the coffee lounge staff.

For Scarborough Museums Debbie Seymour, Esther Graham, Helen
Chattendon, Georgie Samuels, Jennifer
Dunne, Rachel Drew

Rehearsal Chaperones Wendy Wilson, Ellen Mould,
Louise Stanway

Poster and Website Design Callum Nash

Programme Printers Prontaprint, Scarborough

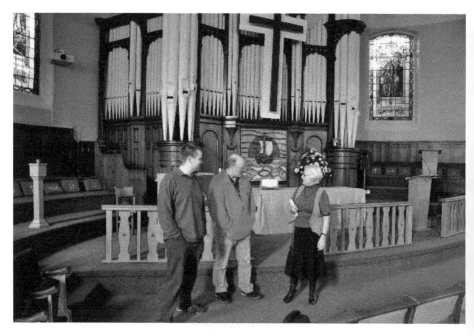

*Fig 81a: Technical production meeting at the acoustically brilliant Westborough
Methodist Church.*

Chapter 7:
Owen's Legacy

Owen's legacy probably appears to young people most often when they are introduced to him and the First World War poets in the English departments of secondary schools across the British Isles. Shrewsbury even has a school named after him and there are now trails and memorials in each of the towns he was associated with. Generous inspirational artwork such as Anthony Padgett's cold cast bronze busts of Owen in the key locations, including Scarborough, together with major exhibitions such as Jennifer Dunne's for Scarborough Museums Trust in 2018, help to keep that legacy alive. Many books have been written about Owen and his poetry and some are listed in the bibliography to this work. The Wilfred Owen Association is at the forefront of maintaining Owen's legacy and regularly publishes articles, reviews and insights into both Owen and the times in which he lived. The poetry is memorable for its powerful imagery and stark sense of reality but it is his message and legacy of peace we would do best to embrace as well as his lasting literary genius.

The legacy is a message for us to peacefully resolve conflict wherever it is possible. The question of whether it is justifiable to go to war is one that increasingly challenges us. In Owen's day, war was possibly seen as a martial crusade of right against wrong without much consideration given to the destruction, heartache and horror it would bring with it. In later wars, there has seemed little alternative but to wage war to halt the march of world

domination by seemingly evil forces of extremism. But Owen saw how 'futile' it all was at the end of the day; conflicts were *not* resolved by war just as they are *not* resolved by war today. The trauma, the pain and the suffering are most often just displaced to another time, another place. The loss of individual life was not, and is not, a futile act in itself; it is often, if not usually, courageous; heroic on a grand scale even, certainly self-sacrificing and in the short term the 'righter of wrongs'. Owen knew this only too well and must have known he was likely to face a violent death himself on the battlefield.

The true legacy of the war poets and all those who strive for peace, is the absence of war and the harmonious dwelling on earth of all people. Perhaps this is an unachievable dream? Perhaps, given human nature, but that is not the point. The point is that Owen showed us how we should strive to avoid the horrors by highlighting, poetically, the very abyss into which we are all capable of sinking. His is a message that we should always have hope and continually strive to achieve peace in whatever ways we can; both individually and collectively. It is this legacy that helped to shape the play *'One Day in December'* and the art installation, *'The Futility of War'*.

The installation is described here in the words of the artist herself as one way of showing Owen's legacy and as an example of the creativity that we can still bring to help achieve peace by the resolution of our conflicts without the necessity of waging war one upon another.

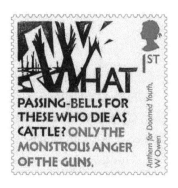

'The Futility of War'

Fig 82: A detail from the five-panel 'The Futility of War' art installation by Angela Chalmers with photographic imagery by David Chalmers. Cyanotype on muslin, 2014.

'David and Angela Chalmers are a husband and wife team who run a photographic studio based at Woodend, Scarborough. They also have their own individual art practices. The sea and coast, woodland and ancient forests greatly inspire David, whilst Angela responds to themes of memory and identity.

Their joint installation 'The Futility of War' accompanies the performance of 'One Day in December.' This is a large-scale textile-based installation using cotton muslin and a historical printing process called cyanotype.

Linked by their interests and passion for alternative photographic techniques, they have responded to Scarborough's memory of the First World War. Their mural-like design depicts elements of war such as deep, dark trenches, shell broken trees and twisted barbed wire, which delicately evolves into representations of nature – plant life, flowers and birds conveying peace and hope from despair, on on-going theme of both the church and the wider community.

Incorporated into the design are images of crumpled-up clothing and ghostly portraits of the cast members of 'One Day' to suggest both human absence and human presence.'

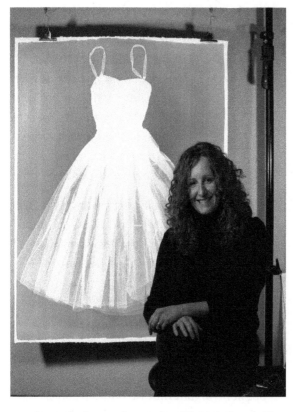

Fig 83: **Angela Chalmers** *is a visual artist based at her studio in Woodend, the former home of the Sitwell family in Scarborough.*

She began her art training in London, later gaining a Fine Art degree from the University of Hull. Her artistic processes include painting, printmaking and photography using a broad range of materials such as ink and acrylic, oil and wax, charcoal, varnish and gold leaf.

Most recently, Angela has been exploring camera-less photography and a Victorian printing process called cyanotype, which was invented by John Herschel in 1842.

Angela produces photograms by placing 3D objects directly onto light sensitive paper or cloth. When exposed to ultraviolet light a chemical reaction occurs generating an insoluble Prussian blue. She uses objects connected to

feminine and domestic functions. These are often items of antiquity, in particular fragments of lace and garments worn for rites of passage; such as a wedding or christening gown. Angela was shortlisted for an award at the 'Photogram Open 2014.' Her work has been shown widely and has participated in exhibitions in London, Sweden and France. Her work is held in private collections worldwide.

'On Futility'

'I called the piece *'Futility of War'* but the artwork is actually about 'Futility' more generally. It's completed in cyanotype; a photographic printing process invented during the early days of photography, a process which had been fast developing since the late 1830s. Cyanotype came along a bit later as another way of printing. It was originally designed to make copies of drawings, hence the word 'blueprint'; that's where the word comes from. The inventor was Sir John Herschel, a scientist and astronomer who worked with Fox Talbot, one of the fathers of modern photography.

Cyanotype involves two chemicals, *ferric ammonium citrate* and *potassium ferricyanide*. When they are mixed together, they become sensitive to UV light. During exposure a chemical reaction occurs and this turns them blue.

I am really attracted to this process. I like the Victorian era, a lot of my work and interest is in that period of time. I can't put my finger on it; maybe I was reincarnated and was actually alive in those times! My recent discovery of Mary Craven, in whose building I now live, and her associations with St Martin's church attracts me greatly as an artist. I was born in Stoke on Trent but I've lived in Scarborough since I was 4 years old so I really feel as though I'm a Scarborian through and through. I was brought up around Peasholm Park and the North Bay area but whenever I came to the south side where I live now, I used to feel really connected to the place.

When I was 40, I went to Hull Uni at the Westwood campus in Scarborough where I studied Fine Art and my subject was 'the human figure'.

One of my ideas was to try and convey an essence of the figure in ice, so I began to research the colour blue. These blue cyanotype images kept popping up and so I learnt the process and I haven't looked back. I also continued to paint and I was very successful. A gallery took me on straight away, I couldn't keep up with demand; mostly inks on paper, monotypes in brown mainly. There's something very Gothic about them, a Victorian seriousness perhaps?

The Installation *'Futility of War'* (2014)

Fig 84: (Cyanotype on muslin in 5 panels)

In early 2014, I was invited to create an artistic contribution to the play *'One Day in December'*, which was due to be performed as a piece of community theatre at Westborough Methodist Church as part of that year's *'Books by the Beach'* literature 'fringe'. The first thing I did was to visit the performance venue; as an artist I need to see the available space. When I saw the big interior glass partition I thought 'that's where it's going to go'. I decided to do what we call an 'Art Installation'. I knew as soon as I saw the space it had to be fabric; I felt there was a feeling of curtaining across the windowed partition which had definite artistic possibilities.

The area contained a large curved area of glass so I knew it would need to be a huge textile-based piece; it was a matter of measuring the space, measuring the fabric and deciding on the choice of cloth. I decided to work

in muslin which I hadn't worked on before but I knew it had potential as it's so transparent. You can actually view the piece from both sides; I decided on five panels to fit the five glass panels of the partition. When you view it from the reverse side you see the reverse image so I felt it had many creative possibilities for the idea of 'futility'. There was a lot of light; it was a good space to work within; I felt people would walk in to see the play and see the piece one way, then walk out at the end and see it another way.

I thought hard about the idea of war and peace and then I read the play script through and summarised it before interpreting what I felt the message Owen was trying to convey actually was. The installation worked very well in the end; it was much admired. The five glass panels of the venue sat in a curve and the panels were completed individually.

The scene is the fictional 'Cliff Top Hotel', Scarborough in modern times where the legacy of war poet Wilfred Owen is all around. Freddie is the schoolboy son of the owners. He hates school and will not study. He hates history and anything to do with Owen. He doesn't want to hear anything about the war; all he wants to do is play computer games. His girlfriend, Roxanne is fed up with all this and is tasked by Freddie's Gran to try and bring him round by whatever means so that he takes recognition of the sacrifices of war. Roxanne does this by suggesting a play, 'One Day in December', with five separate community scenes; she is the heroic long-suffering character trapped by the situation. Roxanne has this image of a wonderful world where everything is perfect; I think this is, in part, an allegory for the post-war view of a 'Land Fit for Heroes'; she is soft, gentle; she wants the sort of life suggested by the 'floating bodice' shown in the first panel. She also wants to 'make it' with Freddie despite his cynical disinterest; she thinks he's worth the investment.

Before I started, I also read some of Owen's poetry; I came across one line about heavy boots in the mud and it was hard not to think about what it must be like to be in a war zone; I know there was hope amongst the feeling of futility and that's what I wanted to try and show; the blue sky, the sea leading again to soft, delicate things and that these should predominate over the evil swilling around below.

This is what the play was about really for me; a re-birth, a sort of heaven out of hell situation. Hell is usually shown low down and heaven is high above us and I thought about these elements. I could have structured it differently with the war zone coming out of the middle but I wanted it to be a landscape, a five-panel landscape based on one overall image. The five panels show different aspects of war; how complex war is, what a mess it causes. Each piece could stand alone.

Each panel took me three days to complete; each piece has two halves with a long UV light exposure requirement, 3 - 4 hours. The effect looks like the sea, or no-man's land; an ocean perhaps washing everything away suggesting nothing is permanent; that our passage on earth, all our worries, are futile in the universal context of time.

The First Panel

Fig 85: Four of the panels depict one of the characters of the play, Roxanne, Freddie, Owen and Gran. Roxanne was the first panel; the image of a female under-slip; it's very feminine; it depicts something beautiful, soft, delicate which matches the face of the girl, Roxanne, (played by Jen Davis). The tree in blossom, a soft image. Then at the bottom is the trench scene, in brown; harsher; this is the contrast required to convey the image of futility.

The first panel seeks to show this; it is feminine like Roxanne; you can see it in her face which conveys the inner sadness of the moment; the realisation that life isn't quite so perfect as she wants it to be but she remains determined that it still *could* be. The slip or bodice is a strong image of what she wants from life. The way the straps of the bodice float in the air gives this ethereal flow of nature at work complemented by the leaves and the ivy. The image of the bodice without anyone in it floating through nature is

very powerful given the back-drop of the war, the widows and all the broken dreams.

The brown is the same initial process but I bleached the blue away and then soaked in tea. The tea acts as a toner because it contains tannins. I used Yorkshire Tea. Of course. The idea was to give a feeling of the trenches moving up to the blue sky above which for me is one of the images of the war. I used barbed wire at the bottom and utilised digital transparencies of photographic faces. The barbed wire is austere meaning 'danger' or 'keep out'. Barbed wire gives a strong image of conflict and barbed wire has become one of the enduring images of the First World War; one of its legacies perhaps. Many people see barbed wire now and their minds immediately go the First World War with all its futility and loss. The birds in the panel represent freedom and the freedom of flight throughout war.

The Second Panel

Fig 86: This is Freddie (played by Mark Palmer). He is shown in a vacuum, a big space. There's no soft focus, no flowers. This time he's shown with birds floating all around his head. He's entangled in barbed wire, its everywhere, all over his face; he can't get out, can't escape; he's fully engaged in his own world and nothing else seems to matter. There's a feeling of a misty swamp in the panel echoing the sodden fields of Flanders in which nothing seems to grow but barbed wire and misery. The panels create a journey, a story starting with a vision of a wonderful world just out of reach, progressing through a vague, ethereal nothingness to the delivery of a message about the wastage of war. Then there is the re-birth, the creation and the awakening before finally there is a resolution with the wisdom of age and experience bearing fruit for the survivors of the conflict. One viewer said he liked the subtle feeling of the hill rising in the distance with the light just showing behind it. He said it reminded him of the lines in the hymn; 'There is a green hill far away' echoing the religious connotations in particular piece Owen wrote in a letter describing his war

172

experience as if he was tending Christ on his cross at Calvary. I felt it must have been a very moving experience for the viewer.

The Third Panel

Fig 87: This is Wilfred Owen himself, (played by Bill Hammond). The central panel; this is what it's all about; Owen's legacy. Wilfred Owen is the catalyst for conveying the imagery of Freddie and Roxanne's essential conflict, the conflict of the legacy too perhaps? Owen appears as an apparition in the play and the panel complements this ghostly quality. He is covered in flowers and the viewer is being asked by Owen to look for that perfect world, that 'Land Fit for Heroes' that the propagandists promised the returning soldiers. Owen looks accusingly out to ask what all the sacrifice of war is about; it is a strong intense look, a beautiful image coming out of the shadows; you only see half of the face, eerie, moving, engaging.

Another viewer of the piece said she liked the idea of the 'leaf-stripped trees' in 'No Man's Land' with the lights of the battlefield on the horizon. She thought it gave a feeling of someone looking out from a trench line across a wasted landscape but on looking up above the battle there was Owen, the war poet and soldier. He was up

amongst the stars looking down in dismay, disgust even, at the terrible mess and destruction war brings to everyone down below who has to suffer its effects.

The Fourth Panel

Fig 88: I wanted to show the play's author in the piece because this forms part of Owen's legacy; the influence on contemporary writers, artists and audiences. In this panel you have a powerful idea of the sea and crashing waves; the idea of the birds soaring freely on the vectors showing the concept of creation; the baby's clothing underlying the barbed wire; the idea of the producer pulling it all together to make a meaningful legacy for a modern audience through community theatre making an impact on young lives today.

The author commented on the panel; 'Producing the play and commissioning the artwork was an act of faith. At times I felt trapped in a tangled web of barbed wire where false moves with managing all the strands would bring painful tears and rips in my own fabric! Having been involved with theatrical productions for many years, I knew that order would eventually emerge and daylight would flood in. I had a feeling the artist could understand this and had sought to capture the situation; as if it was an allegory. I loved the idea of

the 'Doves of Peace' circling over-head; I felt they were keeping watch on all the people in the play who had worked so hard. The birds are shown looking towards each other as if in mutual support whilst giving each other space and the freedom to fly as they wished; It was a pow-erful message and very uplifting for me to see once it was in place. I smiled a lot when I first saw it.'

The Fifth Panel

Fig 89: This is Gran (played by Bar-bara Halsey, (a trained and enig-matic actor), who brought her expe-rience to the play. I wanted the im-age to be suitably feminine; strong and endearing whilst maintaining a sense of growth and embrace. The birds here though are firmly sat on the branches, not flying freely. It's a fixed image; the wisdom of the old grandmother, the tree, trying to have the youngsters see reason, to have a meaningful purpose. It's a softer image; there is less barbed wire. I was thinking how shocking war was; how lives were destroyed. The clothing depicts the lost generation left hanging on the barbed wire of the trenches; the children's clothing flows through the panel, ghostlike, ethereal but also suggesting re-birth and a re-awakening. In this final panel there is a feeling of hope with the barbed wire blown or cut away and a sense of freedom and resolution coming out of the conflict.' There is light on the horizon and the whole image is softer and more hopeful. But all the reminders are still there; a warning for the future.

The Photographic Imagery

For the promotional imagery of the community play *'One Day in December'* *Angela's husband,* photographer David Chalmers, based at Woodend Creative in Scarborough was approached to see if he could produce a piece of iconic artwork that would define the play's central themes of the wastage and loss of war. The artwork was to be used both for the promotional posters and displays of the play and for the programme cover, with the motif running throughout the publications. David later kindly agreed to allow the images to be used for the cover of this book.

Fig 90. (Image copyright to DC Photographic & used with permission)

David Chalmers *has worked in commercial photography for over 30 years. He trained at Blackpool photographic college before an apprenticeship with*

176

London's top advertising photographer Graham Ford working on many prestigious campaigns including BMW and Volvo.

In 1992, David set up his own studio in specialising in still-life photography. Working with many of London's leading advertising agencies. David's past commissions include the Crown Jewels collection for the Tower of London and the 63p Millennium Stamp image for the Royal Mail 'Tree and Leaf' series entitled 'Forest for Scotland'. This work received a 'D & AD' silver award.

David now works from his still-life studio, at Woodend, Scarborough. By embracing the latest developments in digital technology, David continues to undertake commissions from client's worldwide. He also works on personal projects exploring historic processes such as carbon transfer and salt printing. He produces graphic landscape photography that captures local coastlines, ancient forests and wilderness. David also runs workshops in alternative processes from Woodend.

David says of the artistic collaboration:

'As an artist I often have to take time to change from my commercial mode to my artistic mode. I had a brief to produce imagery under the working title of *'Futility'* for the community play *'One Day in December'*. It was to be a single piece of artwork with a series of photographic portraits of the cast to be added to the cyanotype imagery of Angela's.

The imagery was around the legacy of Wilfred Owen; I didn't know too much about his life at that time other than his role as a soldier in the First World War and of course his development as a war poet. But, like many of his contemporaries his experiences must have been almost beyond belief. I am fascinated by the First and Second World War artistry and what the artists tried to show through their work. The Great War was intriguing because it was supposed to be the 'War to end all wars'. So, when you look into the logistics and strategy that went into it all it was appalling at any level.

As an artistic photographer, I felt I was being asked to create a piece of stunning imagery for the play that matched this feeling. I hate war. It is such a waste; a waste of life, a waste of energy, a waste of money. It's one thing in life that really upsets me. I've watched a lot of footage; read a lot about the war and it still upsets me now. Owen encapsulates in his own way much of my own feeling. I wanted to capture this in the piece of art.

The challenge was to try and move people. Can you imagine the fear of 'going over the top'? Of facing your enemy, having no chance, basically being 'lambs to the slaughter'? A lot of those lads didn't know what they were going to face did they? Until it was too late. But we know now. Would I volunteer to fight? Never. Would they have volunteered if they had known? Perhaps; the times were very different but what if nobody agreed to go and fight? Thankfully we, in our generation, haven't been required to fight another global war; perhaps this is part of the legacy of the war poets, of Owen. Perhaps we are learning?

Having thought about the image I wanted to pose these sorts of questions. What was it like to be 'on the edge'? What was it like to know fear? To see all your friends dying around you? They were very moving thoughts and so I tried to focus on this. As an artist, my strength I suppose is in showing things, objects, to their best; I like to show the romantic angle to most things but with war you can't really do that. War is ugly. Really ugly. But you can produce a beautiful and moving image which I think this is although barbed wire by itself is an ugly thing.

And so I worked on the barbed wire, the flowers, the petals of the poppy symbolising blood. The challenge was to create an image in the studio that was abstract but was still beautiful giving off hints of that terror as you peek over the horizon at the unknown; the moment just before you got a bullet through your chest.

When I reflect on it now, five years later, I still think it's a wonderful image; it worked very well then and it still does. Perhaps good art should be timeless? I did wonder at the time if it was a bit too gruesome, but in this context, it had to be. It was a heartfelt piece of art.'

The second contribution David made to 'One Day in December' was to pro-
duce the photographic imagery embedded into Angela's cyanotype installa-
tion. In each of the panels the faces of the actors and producer appear. David
explains the process;

*'Angela was my artistic director for this piece of art. She wanted to work
with portraits of the actors from the play so I knew I had to concentrate solely
on the facial expressions of the principal characters as I saw them before me
on the day of the shoot. I had to capture each of the images then isolate them
so that Angela could use the negative within the cyanotype which she has
done really well. The final facial images are ghostly, haunting images staring
out, almost accusingly. The two techniques blended well and the final effect
was both dramatic and moving.'*

In interview, David explained about the legacy of this art work. He said that
soon after they had completed the installation Angela and he had been in-
vited to France to take part in a group exhibition called 'Territoires'. Newby
and Scalby, two adjacent constituent 'villages' of Scarborough, are twinned
with Pornic in France and the idea of collaborating with other international
artists appealed. They travelled to Pornic as part of a larger group of artists
and stayed there working on the exhibition for three weeks. Then followed
the return of the French artists to Woodend, accompanied by the Mayor of
Pornic, where the 'Futility of War' installation was discussed. Despite the lan-
guage barrier, a common view was established about the susceptibility of
people *en masse* to be influenced by the views of a minority. The mass 'brain-
washing of a generation' to fight a war was compared to the modern political
battleground and the question of Europe. Both groups of artists were unified
in the view that art, literature and music have their place in addressing the
constant issues of the world. Perhaps, art conquers all. As David said;

*'We as artists are addressing our own world through our art. I thought of
the 'One Day in December' imagery of the barbed wire and the oceans of
split blood; of the nature of conflict and confusion and said to myself 'Here*

we are again'. Conflict in Europe with the creation of the conditions for further conflict rather than resolution. There was a subtle thread of legacy running through both the play and our 'Territoires' exhibitions at Pornic and Woodend. Legacy is all about something being left behind or handed down by those who went before; Owen left his mark here; we created images from that legacy and now we have left our mark on the present. It is all part of what we do as artists, writers, photographers, entertainers. We take a legacy, interpret it and pass it on.'

Fig 91: The designer's mock-up of the book using the 'Futility' photographic imagery. (Photo courtesy of Liam Kitto)

Footnote: Throughout the week of the exhibition, a display was mounted in a side room at Westborough Church showing various aspects of the First World War in Scarborough. The Scarborough Maritime Heritage Centre lent their pull-up banners as well as some papers, photographs and artefacts to add to the private family collection of the author. Over 200 people visited the display during the week and many made appreciative comments. We were grateful to the Maritime Heritage Centre, the Scarborough Museum's Trust and to Len Friskney and his family for the loan of the additional material that made for a useful insight into Owen and the war in the area.

From the Visitors' Book

Many people commented on the various strands of art in the production and many left remarks in the production visitors' book. Some of these concerning the imagery included;

'There is something very moving about the barbed wire and the poppies; the idea of the silhouette – it's like looking through the gas and the mist of the trenches in Flanders'

'The imagery in both the cloth and photos images reminds me of an ocean. Owen would have looked down from his windows and seen the sea. Maybe he was saying 'Beyond the sea is my death?' There is France; I am going to die there. Every morning he must have seen that.'

'I like the light coming out from the tunnel'

'A beautiful piece of art.'

'The posters are very evocative in the large scale and you cannot fail to be moved by the imagery; there's something very dark and haunting about them.'

'I like all of the art from the play and the installation because it's abstract; you're not quite sure what's going on but it's a strong image and makes you think about all of the issues in the play.'

'It's a ghostly image. I could feel the battlefield in the pictures; it's a huge landscape portrait really isn't it? A flat picture has been given great depth.'

'The progression from the blue down to the brown; the blood and the mud all mixed up; it's a great contrast against the delicacy.'

Postscript

On the 12th September 2018, the legacy of Wilfred Owen continued to inspire with the launch of the 'Owen Map and Trail' at Newby and Scalby Library in Scarborough. In the research for that event another local connection was discovered. One of the library trustees, Lesley Newton, who is a keen historian in her own right and former secretary at Scalby School, revealed that Leslie Gunston, Owen's first cousin and literary confidante, as well as his best friend for most of his life, had left a number of paintings to Lesley's mother where he had once lodged. A small connection perhaps but one that helps to keep the legacy alive.

In August 2019 this book is due to be launched at St Martin's on the Hill Church in Scarborough, itself connected to this story through the artist, Angela Chambers, who produced 'The Futility of War' and who is the artistic curator at the church. The church is described on their website in the following description:

'St. Martin's is the perfect High Victorian Church, and was built in response to the rapid urban development of The South Cliff that had taken place since 1845.

The church was designed by George Frederick Bodley from Hull. He was commissioned by Miss Mary Craven, a spinster, also originally from Hull, whose generosity ensured the success of the project. Bodley employed the newly formed firm of Morris, Marshall, Faulkner and Company to complete the internal decoration and stained glass, and the church was consecrated in July 1863.

The windows exhibit designs by William Morris, Sir Edward Burne-Jones, Dante Gabriel Rossetti, Philip Webb and Ford Madox Brown, while the pulpit, and east wall are decorated with paintings designed by Rossetti, Morris and Burne-Jones.

The form and furnishings of the church are the product of the medievalism of Victorian art. St. Martin's remains today the physical and spiritual heir to the love of ritual and worship inspired by the Oxford Movement of the 1840s. The church represents an increasingly precious inheritance in art, history and worship.'

Additionally, Angela and David Chambers now live in the former residence of Mary Craven who was a major benefactor of the church's construction. Gunston was a supporter of the Oxford Movement, Owen of a belief that they were outdated in their poetic endeavours; but we are all connected by legacy in one way or another. But what will the next generation make of it all once the 100th anniversary commemorations begin to fade in the memory? We shall see.

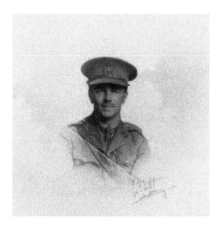

Select Bibliography

Bell J. 'Wilfred Owen: Selected Letters' Oxford University Press 1998

Cuthbertson G. 'Wilfred Owen' Yale University Press New Haven 2014

Emden R. van 'All Quiet on the Home Front' Headline London 2003
& Humphries S.

Gray S. 'Reciting Wilfred Owen' Wilfred Owen Association 2018

Hibberd D. 'Wilfred Owen: The Last Year' Constable London 1992

Marsay M. 'Bombardment! The Day the East Coast Bled'
 Great Northern Publishing Scarborough 1999

Mcphail H. 'On the Trail of the Poets of The Great War: Wilfred Owen'
& Guest P. Pen & Sword Barnsley 2001

Owen H. & Bell J. 'Wilfred Owen: Collected Letters' Oxford University
 Press 1967
Pearson J. 'Facades: Edith, Osbert, & Sacherverell Sitwell'
 Bloomsbury 1978

Potter J. 'Wilfred Owen. An Illustrated Life' Bodleian Library
 Press Oxford 2014

Read L. 'Thunder in the Morning' Privately published through
 York Publishing Services 2005

Riley M. 'Haunted Scarborough' The History Press 2010

Sitwell O. 'Noble Essences' MacMillan 1950

Stallworthy J. 'The Poems of Wilfred Owen' Chatto & Windus 2004

D.B. Lewis is a full-time writer and lecturer living in Cloughton on the North Yorkshire coast of the U.K. His interest in Wilfred Owen was kindled by a Workers' Educational Association programme at Scarborough concentrating on Owen and the 'War Poets' from which he went onto become a member of the Wilfred Owen Association. David specialises in biography, reminiscence and all forms of memoir. He is particularly involved in writing support to emerging and established authors and is the current chair of the International Police Association's Global Writers' Forum. David is an Associate Lecturer with the London Policing College and travels extensively in the UK and abroad. He holds degrees in Creative Writing and Adult Education, is a Fellow of the Chartered Institute of Personnel and Development and a member of the Institute for Leadership and Management. He is a former Fulbright Fellow at the Pennsylvania State University and runs an inspirational literacy project for young people of all ages called 'Stories for All' which uses a 1968 Police Morris Minor called 'Stan' to encourage creative story writing. David is a 'Literacy Champion' for the National Literacy Trust. 'One Day in December' is his sixth book.

Len Friskney, with his twin brother Norman, was born in Sheffield in 1941 where his father was serving in the Royal Artillery before being posted overseas. At the end of the war his father moved the family to Scarborough to open a newspaper shop on Sandside. Len attended Friarage School where he left aged 15 to take up an apprenticeship on the Scarborough Evening News under Sir Meredith Whittaker. In 1971, Len moved to The Northern Echo at Darlington. After 40 years in the printing trade he joined Lloyd's Bank before finally returning to Scarborough in 2000 where he took up a post at the Clifton Hotel. Len is a keen local historian having written many articles on Owen, the First World War and other military subjects. He is a former soldier with the 4th/5th Battalion, The Green Howards, later the Yorkshire Volunteers, where he holds the TA&VR Efficiency Medal.